Origami Insects and Their Kin

Step-by-Step Instructions in Over 1500 Diagrams

Robert J. Lang

Photography by Phillip Doyle

DOVER PUBLICATIONS, INC.
New York

Published in Canada by General Publishing Company, Ltd., 30 Lesmill Road, Don Mills, Toronto, Ontario.
Published in the United Kingdom by Constable and Company, Ltd., 3 The Lanchesters, 162–164 Fulham Palace Road, London W6 9ER.

Design, illustration, and layout by Robert J. Lang
Software: Aldus Freehand 3.1, Color-It 2.3 and proprietary PostScript extensions
Hardware: Macintosh SE + Novy Quik30 Accelerator, Macintosh Quadra 700
Imagesetting: Hunza Graphics, Berkeley, California
Macintosh is a registered trademark of Apple Computer, Inc.
Novy and Quik30 are registered trademarks of Novy Systems, Inc.
Aldus Freehand is a registered trademark of Aldus Corp.
Color-It is a registered trademark of MicroFrontier, Inc.
PostScript is a registered trademark of Adobe Systems, Inc.

Bibliographical Note

Origami Insects and Their Kin: Step-by-Step Instructions in Over 1500 Diagrams is a new work, first published by Dover Publications, Inc., in 1995.

Manufactured in the United States of America
Dover Publications, Inc., 31 East 2nd Street, Mineola, N.Y. 11501

Library of Congress Cataloging-in-Publication Data

Lang, Robert J.
 Origami insects and their kin : step-by-step instructions in over 1500 diagrams / Robert J. Lang ; photography by Phillip Doyle.
 p. cm.
 Includes bibliographical references.
 ISBN 0-486-28602-9 (pbk.)
 1. Origami. 2. Insects in art. I. Title.
TT870.L2616 1995
736'.982—dc20 95–50
 CIP

To the Memory of Alice Gray
1914–1994

Contents

Introduction **4**

Symbols and Terms **6**

Procedures **7**

Treehopper **10**

Spotted Ladybug **14**

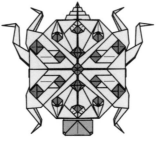
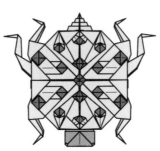
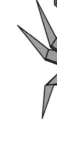

Orb Weaver **19**

Tarantula **24**

Tick **29**

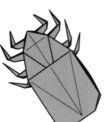

Ant **34**

Butterfly **40**

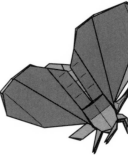

Scarab Beetle **46**

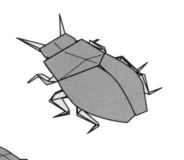

Cicada **52**

Grasshopper **59**

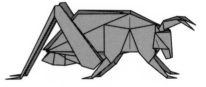

Black Pine Sawyer **66**

Dragonfly **74**

Hercules Beetle **82**

Long-Necked Seed Bug **90**

Pill Bug **98**

Praying Mantis **106**

Stag Beetle **114**

Paper Wasp **122**

Samurai Helmet Beetle **132**

Scorpion **143**

Acknowledgments **155**
Sources **155**

Introduction

The great British naturalist J. B. S. Haldane was once asked by a reporter which characteristics of the Creator he could infer from his studies of Nature. He reportedly replied, "an inordinate fondness for beetles." It is estimated that the number of recorded species of beetle is somewhere around 450,000, making beetles by far the most diverse group of animals on this planet. The total number of catalogued insects is estimated at over 1,000,000 different species. Just what peculiar fascination insects bore for the original Creator remains a mystery. Whatever it was, today a similar fascination is shared by the origami creator.

Insects have always been among the most challenging of origami subjects, owing to their many long, slender appendages, which require origami bases with many long, slender points. Points are fundamental elements of origami design. Obtaining a base with a few points is easy; achieving many points from a single uncut square of paper is far more difficult. While many folders have historically used cuts, multiple sheets, or the imagination of the observer to produce the legs, wings, and antennae of an insect, there have also been a number of folders—myself among them—for whom the accurate representation of our jointed-legged friends using the purist's rules of origami—one square, no cuts—has held a particular appeal, drawing us like moths to a flame.

The technical developments in origami design of the past decade have made it possible for us insectophiles to finally indulge our passion for jointed-legged paper creations. In the past, origami designers began from one of a small number of existing bases and made small modifications to obtain new models. There was only one base—the Blintzed Bird Base—that possessed sufficient points to make six legs plus antennae or wings, and good insect designs were few and far between. Now, however, the art and science of origami have progressed to the point that the modern origami designer can construct a unique base with precisely the number, length, and location of points to make any desired shape. The effect that the techniques of technical design have had on modern origami has gone beyond a post-Cambrian explosion of paper beetles, butterflies, and bugs: freed from the necessity of concentrating on numbers of points to the exclusion of all else, origami designers can focus their efforts instead on the esthetics of folding, rather than upon getting enough flaps; on developing life, rather than upon meeting a parts count.

This book contains twenty designs for origami insects, spiders, and related creatures, for the origami and entomological enthusiast. In this collection, I have tried to provide a varied selection of subjects, folding styles, and techniques. All of the models in this book can be successfully folded from standard 25 cm (10 in) square origami paper, although in many of them, some especially artistic

effects are possible with use of foil-backed paper or wet-folding techniques. The models were invented over a period of several years, and therefore show not only an evolution in folding style, but an evolution of influences as well. The Butterfly was inspired by a model of the same subject by Peter Engel; the Spotted Ladybug was inspired by the striped and spotted creations of John Montroll; and the Samurai Helmet Beetle was inspired by a design of Seiji Nishikawa. Less overt influences permeate the rest of the models, for I admit that I get my ideas and techniques from everywhere I can. Or, as Picasso once said, "Good artists borrow; great ones steal."

And I hope you will steal—or at least borrow—from me. Each of the models represents a different subject and a different base, symmetry, or technique as well. I have purposely tried to vary the details, as well as the bases, using different techniques for thinning points, for making legs, and so forth. None of the designs here should be regarded as sacred; I encourage you to experiment, folding them differently, seeing if you can fold different types of insects from the same basic shape. Most importantly, if you would like to learn how to design your own insects, by all means pull the finished model apart to see how it went together and why the initial folds were made where they were. Although the pre-creasing sequences for many models may appear to be arbitrary, every fold's location is chosen for a specific symmetry, and it is a fun challenge to figure out what that symmetry is.

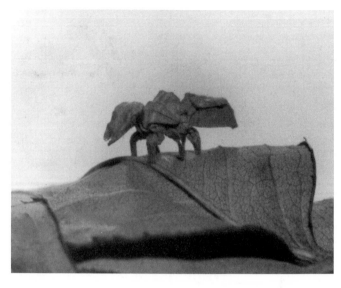

I hope that these models will be fun to fold and a pleasure to view. One thing they will not be, however, is easy. In origami, many points mean many folds, and all of these models have long folding sequences—this book is not for the origami novice. The simplest model here is at a level of difficulty that would earn it the highest complexity rating at an origami convention. In addition to their long folding sequences, many of the models also require a little something extra—a closed sink here, a closed un-sink there, or some other manipulation that may tax your dexterity. Much of the appeal of origami comes from the challenge of successfully folding a model, and the most difficult designs here will prove a challenge for even the advanced folder. Therefore, a basic familiarity with the conventions and terminology of origami and some experience folding complex models is in order. That said, the instructions for the models are complete (although they may be difficult) and have been tested on a number of folders; somewhere, someone has folded everything in this book. Each model was a challenge for me to design. I hope you enjoy the challenge of folding them!

Robert J. Lang, 1995

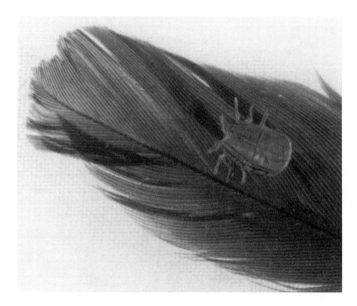

Symbols and Terms

The instructions for the models use the line and arrow notation originally developed by Yoshizawa and popularized in the West by Randlett and Harbin. Each model begins from a square and proceeds through step-by-step drawings. Each drawing shows the result of the previous step, and what action is taken next. Before performing the operation shown in a given step, it is a good idea to look ahead to the next step, or next several steps, to see what the result will be.

Although the drawings are intended to be sufficient to fold each model, verbal instructions are provided for each step for additional clarification. The terms "upper," "lower," "top," "bottom," "left," "right," "horizontal," and "vertical" refer to the dimensions of the page itself: "toward the top" means "toward the top of the page," for example. The terms "front" and "near" refer to location or motion perpendicular to the page, that is, toward the folder; the terms "far," "behind," and "back" refer to location or motion away from the folder. The terms "in" and "inward" mean toward the middle of the model; the terms "out" and "outward" mean away from the middle. An edge can be a folded edge or a raw edge, which is part of the original edge of the square. These terms are illustrated below.

Origami Lines

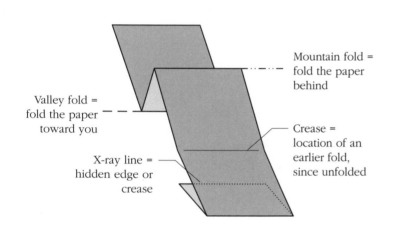

Valley fold = fold the paper toward you

X-ray line = hidden edge or crease

Mountain fold = fold the paper behind

Crease = location of an earlier fold, since unfolded

Origami Symbols

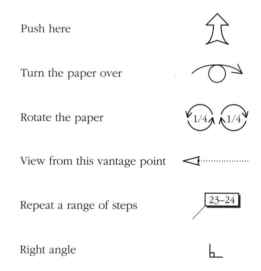

Push here

Turn the paper over

Rotate the paper

1/4 1/4

View from this vantage point

Repeat a range of steps

23–24

Right angle

Origami Terms

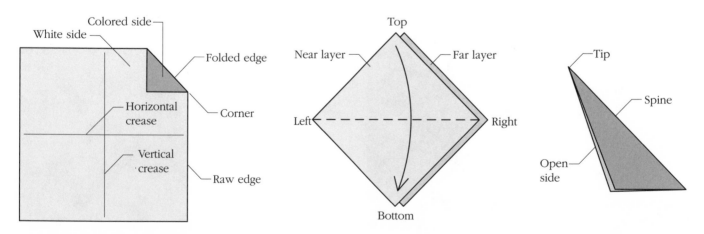

Colored side

White side

Folded edge

Horizontal crease

Corner

Vertical crease

Raw edge

Top

Near layer

Far layer

Left

Right

Bottom

Tip

Spine

Open side

Procedures

The basic folding procedures — inside and outside reverse folds, squash and petal folds, rabbit ears, crimps, and pleats — are described in many origami books, and you should be familiar with the procedures (if not the names) before you tackle the models in this book. (For a list of books with more extensive descriptions of the procedures, see Sources, p. 155.) An example of each of the basic procedures along with its name is given below.

Valley Fold

A valley fold — the most common origami fold — is denoted by a dashed line and an arrow with a symmetric head.

Mountain Fold

A mountain fold is used when you fold a flap away from you. It is denoted by a dot-dot-dash line and a hollow one-sided arrow.

Unfold

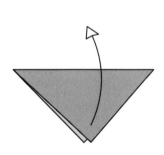

Unfolding a previously made crease is denoted by a symmetric hollow arrow.

Crease (Fold and Unfold)

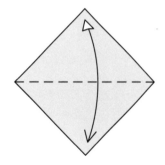

When you fold a flap and immediately unfold it (usually to make a reference mark or a crease for later use), the arrow will have a valley fold arrowhead at one end and an unfold arrowhead at the other.

Inside Reverse Fold

An inside reverse fold changes the direction of a flap by pushing its spine down between its edges and turning the tip inside-out.

Outside Reverse Fold

An outside reverse fold wraps the raw edges of the moving flap around the spine.

Rabbit Ear

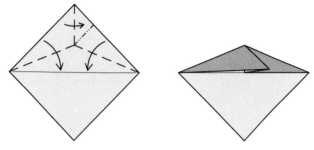

A rabbit ear is usually formed by bisecting all three angles of a triangle and swinging the point to one side or the other to flatten.

Squash Fold

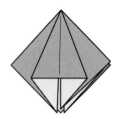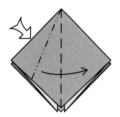

A squash fold is formed from a flap with at least two edges along one side; the two edges are spread apart, and the one flap turns into two shorter ones.

Petal-Folding a Point

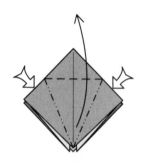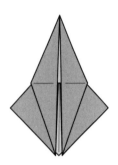

There are two types of petal fold. The way shown here lengthens and narrows a point.

Petal-Folding an Edge

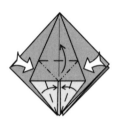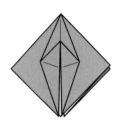

The other type of petal fold takes an edge and turns it into a point, as shown here.

Pleat

A pleat is formed by folding the paper back and forth in a zig-zag fashion.

Crimp

A crimp is a multilayered pleat in which the near layers form the mirror image of the far layers. You can make crimps by either unfolding the paper and pleating, or by two successive reverse folds.

Open Sink Fold

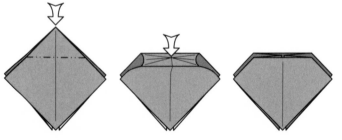

The sink fold inverts a point that has no raw edges. A sink is an open sink if the point is completely opened out halfway through the fold as shown here.

Spread Sink

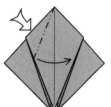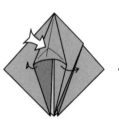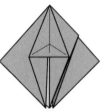

A spread sink flattens a point that has no raw edges. It is also an easy way to make an open sink if you close it up afterwards.

In addition to the well-known basic folds, several of the designs in this book make use of two lesser-known procedures that are rather more difficult to carry out. If you are unfamiliar with these procedures, you might wish to fold some examples as practice before you undertake a model that uses one of them; if you encounter one in a model for the first time, you should put the model aside and use a different piece of paper to practice the maneuver until you can do it neatly and cleanly.

Closed Sink

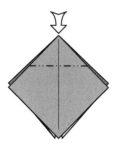 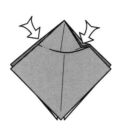 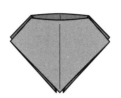 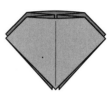

The closed sink looks like an open sink, but instead of opening out the point, you "pop" it inside-out without unfolding it.

One way of making a closed sink is to invert the pyramidal point, beginning at the rim of the sink.

The corners of a closed sink are linked together, while those of an open sink are loose. Compare a closed sink…

To an open sink.

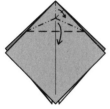 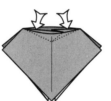 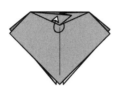 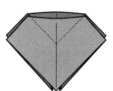

Here is an easy way to make a closed sink. First, fold a rabbit ear from the point.

Then bring a single layer in front of the rabbit ear.

Finally, push the edges of the rabbit ear down inside the hole, turning it completely inside-out.

Finished closed sink.

Open and Closed Unsinks

The unsink is exactly the opposite of a sink. In a sink, you turn a point into a pocket; in an unsink, you turn a pocket into a point. And as do sinks, unsinks come in both open and closed varieties.

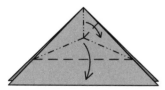 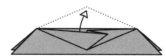 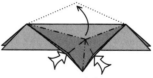 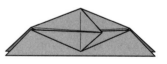

Here is a shape you can practice open and closed unsinks upon.

An unsink is indicated by the arrow that shows to pull some paper out. The difficulty is that for open unsinks, there is nothing to grab on to!

Here is a way of doing some open unsinks. Open the pocket slightly and push in the sides so that only a single layer bulges upward.

Then flatten the paper.

A closed unsink is indicated the same way as an open unsink.

In a closed unsink, though, you can reach inside the pocket and grab an edge to pull out.

Finished closed unsink.

Just for practice, you should do the other side, too!

◆ Treehopper ◆

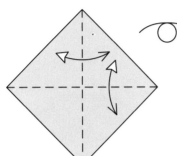

1. Begin with the white side up. Fold and unfold along the diagonals. Then turn the paper over.

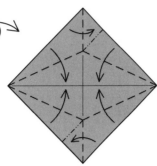

2. Fold a Fish Base with the points going in opposite directions.

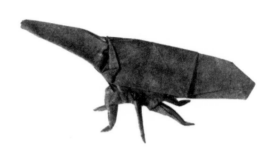

The Treehopper is an insect that hides from predators by mimicking a thorn. When it clings to a twig, its green or brown body blends in with the stem and the horn on its head resembles a smaller twig or thorn. Under cover of camouflage, the treehopper sucks the juices out of the plants it clings to, and is therefore considered a pest by gardeners.

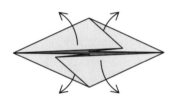

3. Unfold to step 1.

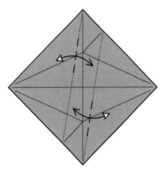

4. Fold and unfold. Make the crease sharp only where it crosses the creases of the Fish Base.

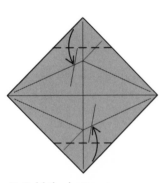

5. Fold the bottom corner up so that its right edge hits the intersection of the two creases; repeat above.

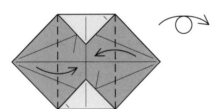

6. Fold the sides in and turn the model over.

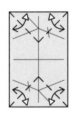

7. Fold and unfold.

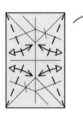

8. Fold and unfold; then turn the model back over.

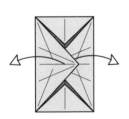

9. Unfold the sides.

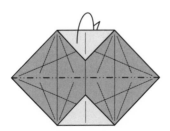

10. Mountain-fold the model in half.

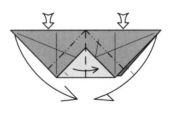

11. Squash-fold the left side in front and the right side behind.

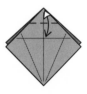

12. Fold and unfold.

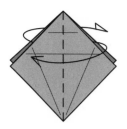 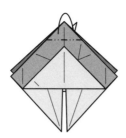 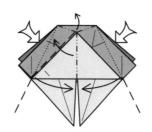 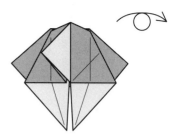

13. Fold one flap to the left in front and one to the right behind.

14. Mountain-fold the point behind on the existing crease.

15. Bring the sides of the white triangle together and swing it over to the left.

16. Turn the model over.

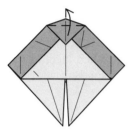 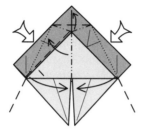 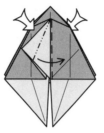

17. Fold the point upward.

18. Repeat step 15 on this side.

19. Squash-fold the white flap; repeat behind.

20. Petal-fold the edge; repeat behind.

21. Unwrap a single layer of paper; repeat behind.

22. Petal-fold the bottom point upward; repeat behind.

23. Fold the flap down; repeat behind.

24. Wrap one layer to the front; repeat behind.

25. Open up the model and crimp the sides in; you will wind up with a square shape.

26. Turn the model over.

27. Fold and unfold; turn the model back over.

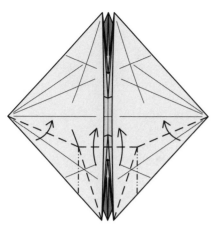 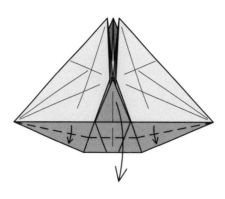 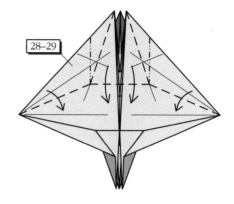

28. Fold two linked rabbit ears (like a stretched Bird Base).

29. Fold the group of three points downward.

30. Repeat steps 28–29 on the top.

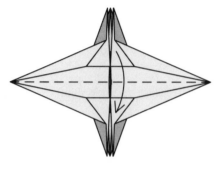 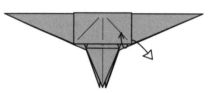 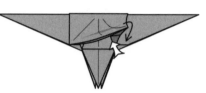

31. Fold the model in half.

32. Release the trapped layer so you can lift the corner upward.

33. Fold the flap back down; repeat steps 31–32 on the left and on both sides behind.

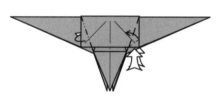 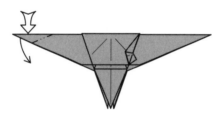 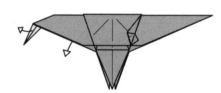

34. Mountain-fold the corner on the left; squash-fold the corner on the right. Repeat behind.

35. Reverse-fold the corner downward.

36. Pull out the raw edge of the paper. Repeat behind.

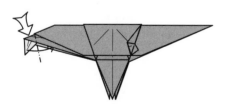 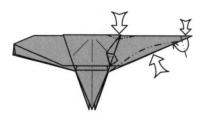 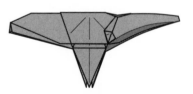

37. Reverse-fold the corner into the model.

38. Reverse-fold the tip of the horn at the right and shape it with mountain folds.

39. Like this.

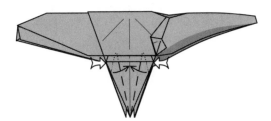

40. Spread-sink the corners.

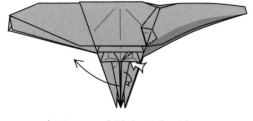

41. Reverse-fold the right side of the flap upward to the left.

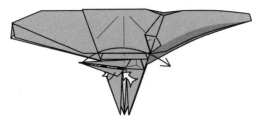

42. Reverse-fold the left side of the flap in the same way and swing it over to the right.

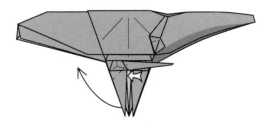

43. Reverse-fold the left point up to the left.

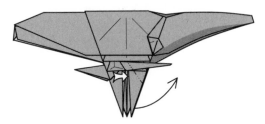

44. Reverse-fold the right point up to the right.

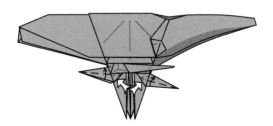

45. Narrow the legs with reverse folds.

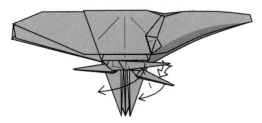

46. Valley-fold the middle leg down to the left. Reverse-fold the foreleg downward.

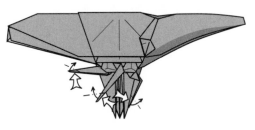

47. Reverse-fold feet on all three legs.

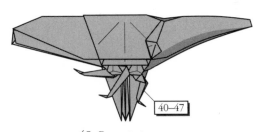

48. Repeat steps 40–47 on the far side.

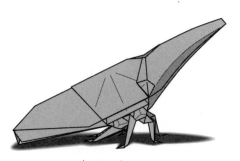

49. Treehopper.

◆ Spotted Ladybug ◆

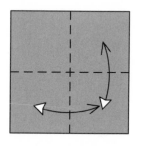

1. Fold the paper in half and unfold.

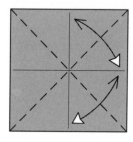

2. Fold and unfold.

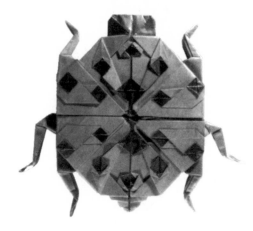

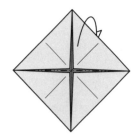

3. Fold the corners to the center.

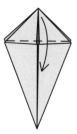

4. Fold the top point behind.

Ladybug beetles are a large family of insects, recognizable by their round bodies and distinctive patterns of spots. The number of spots depends on the species, and can vary from one or two up to as many as twenty-three. Ladybugs are voracious predators of aphids and other garden pests, and in the Middle Ages were dedicated to "Our Lady" in appreciation of their service—which is how they got their name.

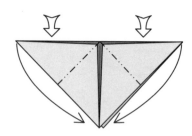

5. Reverse-fold the two points downward.

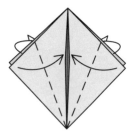

6. Fold the edges in to the center; repeat behind.

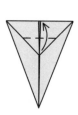

7. Fold the top point down over the folded edges.

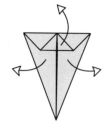

8. Fold the point back up to the top.

9. Unfold to step 6.

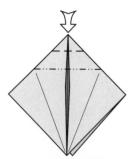

10. Sink in and out on the existing creases.

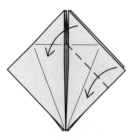

11. Pull out four loose flaps as far as possible.

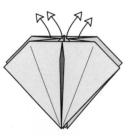

12. Fold one flap down to the left.

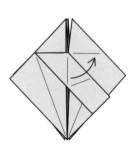

13. Unfold.

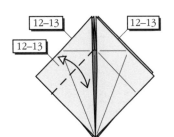
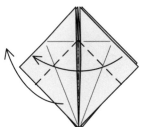
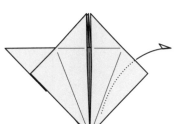
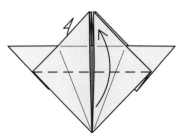

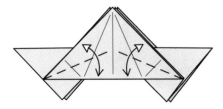
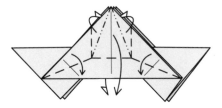
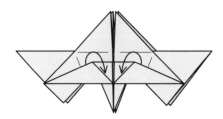

14. Repeat steps 12–13 on the left and on both sides behind.

15. Lift up one flap and swing it to the left.

16. Repeat step 15 behind.

17. Fold one flap up in front and behind.

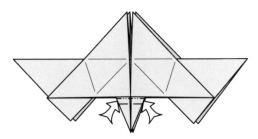
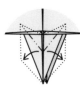

18. Fold and unfold through a single flap. Repeat behind.

19. Fold two interlocking rabbit ears. Repeat behind.

20. Bring one layer of paper to the front. Repeat behind.

21. Crimp the point in and out; repeat behind. (Three layers are are on top in the crimp.)

22. Pull out a single two-ply flap of paper from the top on each side. (Do not repeat behind.)

23. Squash-fold.

24. Wrap a single layer to the rear.

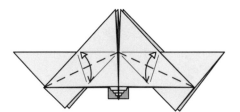

25. Turn the paper over.

26. Crimp the point in and out.

27. Like this.

28. Fold and unfold. Repeat behind.

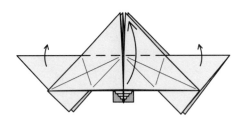
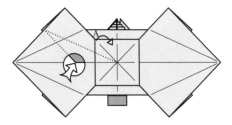

29. Lift up the bottom of the model.

30. Pull some paper out at point A. The action is started by sinking the hidden point while stretching point A.

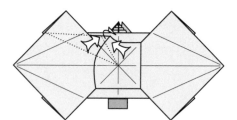

31. Tuck the excess paper to the right and flatten.

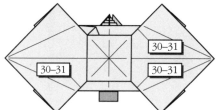

32. Repeat steps 30–31 on the other three corners.

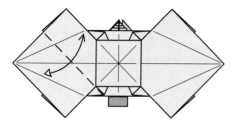

33. Fold and unfold.

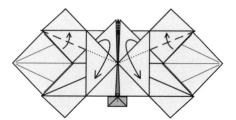

34. Repeat in three places.

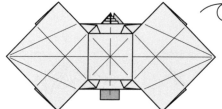

35. Turn the model over.

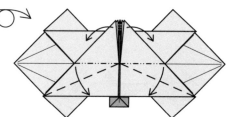

36. Pleat two layers.

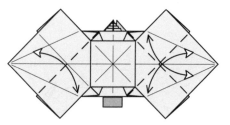

37. Pleat the other two layers over the first.

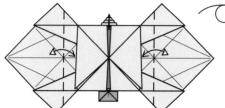

38. Fold and unfold through the intersection shown. Then turn the paper over.

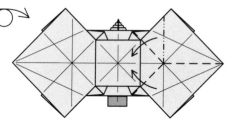

39. Fold a rabbit ear through all layers.

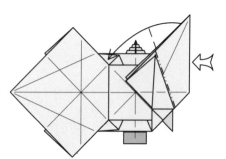

40. Reverse-fold the point.

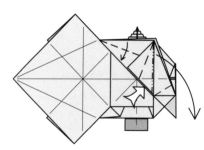

41. Stretch the point downward and to the right.

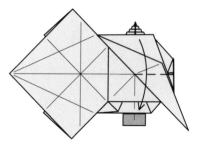

42. Fold the point down.

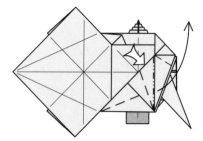

43. Repeat step 41 on the top.

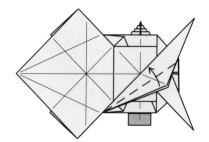

44. Fold one edge up.

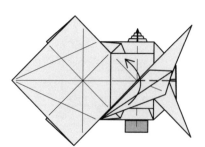

45. Fold the flap upward.

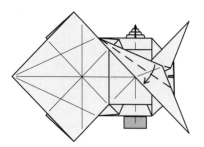

46. Fold the edge downward.

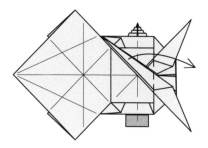

47. Fold the point over to the right.

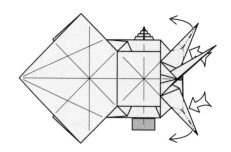

48. Double-rabbit-ear the two thick points.

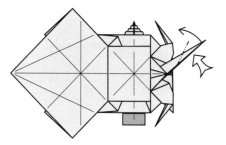

49. Reverse-fold the middle leg.

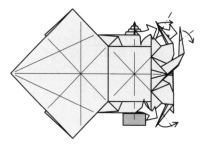

50. Reverse-fold the tips of all three legs.

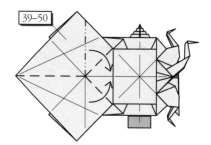

51. Repeat steps 39–50 on the left.

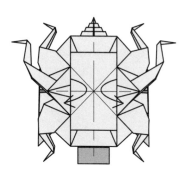

52. Bring some loose paper to the front.

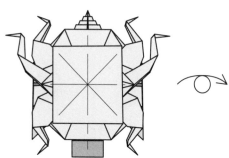

53. Turn the model over.

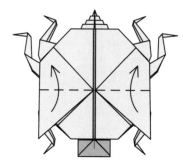

54. Fold two flaps upward.

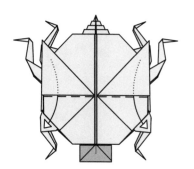

55. Pull out the trapped flap on each side.

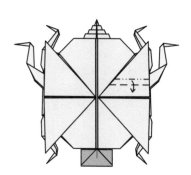

56. Pleat one flap.

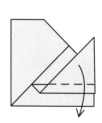

57. Detail of upper right quadrant. Fold the tip down over the pleat.

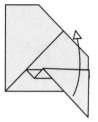 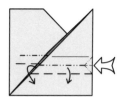 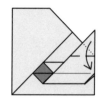 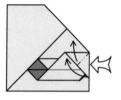

58. Unfold the pleat.

59. Push in the edge and pleat; note that the front and back side are pleated on different creases.

60. Fold down the tip of the point where the hidden edge hits the right side.

61. Squash-fold the point.

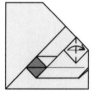 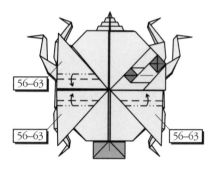 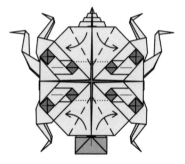

62. Fold the tip of the point to the right.

63. Mountain-fold the corner underneath. Fold all the layers together as one.

64. Repeat steps 56–63 on the other three flaps.

65. Fold a pair of edges outward on each side, top and bottom. Note that a tiny gusset forms where each valley fold hits the center line.

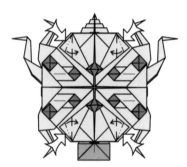

66. Squash-fold the four corners. The valley folds are vertical.

67. Detail of upper left quadrant. Fold a small petal fold. The colored region becomes diamond-shaped.

68. Slightly squash-fold the edge that lies under the triangular white flap.

69. Repeat steps 67–68 on the other three flaps.

 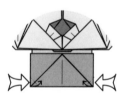 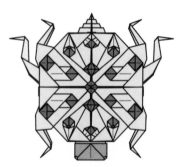

70. Mountain-fold the four corners in the middle underneath (only one is shown here).

71. Reverse-fold the corners of the head.

72. Spotted Ladybug.

◆ Orb Weaver ◆

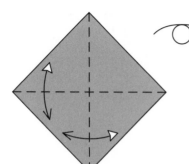

1. Fold and unfold along the diagonals. Turn the paper over.

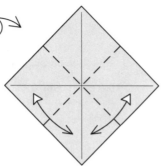

2. Fold and unfold along the sides.

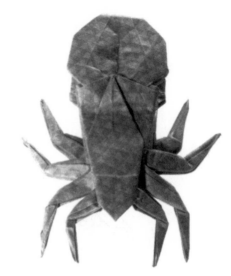

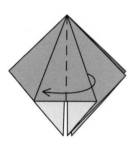

3. Fold a Preliminary Fold.

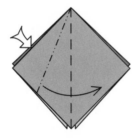

4. Squash-fold an edge.

Spiders, although they look like insects, are not; they are called arachnids, and are distinguished from insects by having eight legs (all insects have six) and only two body segments (insects have three). There are over 75,000 named species worldwide. Most spiders have the ability to spin fine strands of silk. Although some species use the silk only for lining their burrows or to ride the wind, several are known for spinning large, symmetric, elliptical meshes in which they catch their prey.

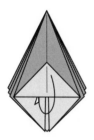

5. Fold one layer back to the left.

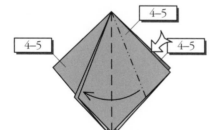

6. Repeat steps 4–5 on the right and on both sides behind.

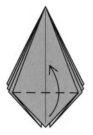

7. Fold up one layer.

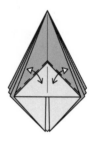

8. Fold and unfold through two plies of paper on the left and right.

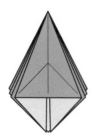

9. Fold the flap underneath.

10. Turn the paper over.

11. Repeat steps 7–9 on this side.

12. Fold two layers to the right in front and two to the left behind.

13. Repeat steps 7–9 on this side and behind.

14. Fold the thick top point down to the bottom edge and crease sharply.

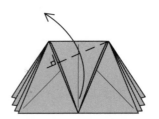

15. Fold the thick point up to the left. Crease sharply.

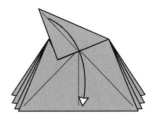

16. Unfold.

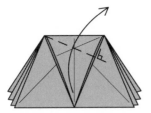

17. Fold the thick point up to the right. Crease sharply.

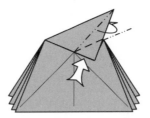

18. Reverse-fold the corner as you swing four layers at the top to the left.

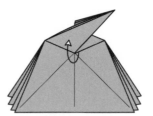

19. Bring one layer of paper to the front.

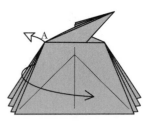

20. Fold one flap to the right, releasing the trapped layers at corner A.

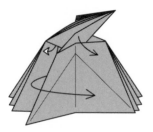

21. Pull the trapped paper out, releasing the corner.

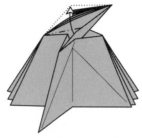

22. Pull out a single layer of paper as far as possible.

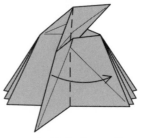

23. Fold the layer all the way over to the right and flatten.

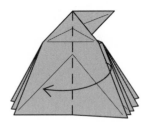

24. Fold the layer back to the left.

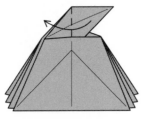

25. Fold the top point to the left.

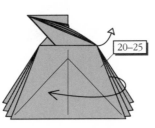

26. Repeat steps 20–25 on the right.

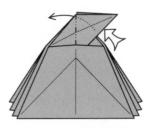

27. Reverse-fold the point to the left.

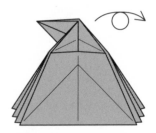

28. Turn the model over.

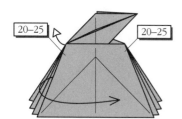

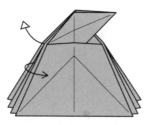

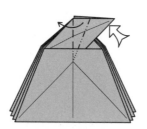

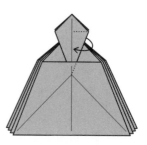

29. Repeat steps 20–25 on both the left and right.

30. Release the remaining trapped layers. Repeat on the right.

31. Squash-fold the point.

32. Bring one layer (with two attached edges) to the front.

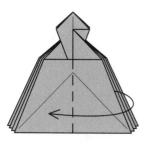

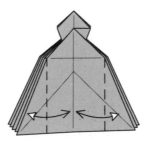

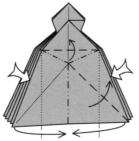

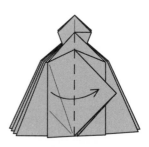

33. Fold one layer over to the left.

34. Fold and unfold.

35. Squeeze the sides in and swing the excess paper up and to the right.

36. Fold one flap back to the right.

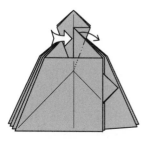

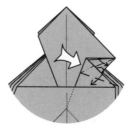

37. Reverse-fold the corner.

38. Swivel-fold a double layer of paper.

39. Release a single trapped layer.

40. Wrap one layer from front to back.

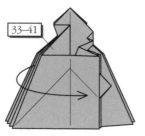

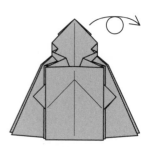

41. Reverse-fold (or, if you're feeling daring, closed-sink) the corner.

42. Bring one layer to the front on the right.

43. Repeat steps 33–41 on the left.

44. Turn the model over.

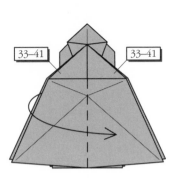

45. Repeat steps 33–41 here and on the right.

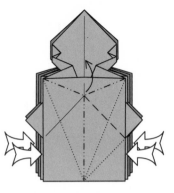

46. Squeeze the sides in and swing the excess paper over to the right. Repeat behind.

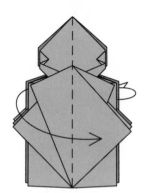

47. Fold two layers to the left in front and two behind, releasing any trapped layers.

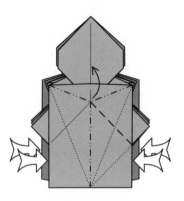

48. Squeeze the sides in and swing the excess paper over to the right. Repeat behind.

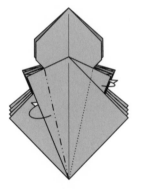

49. Mountain-fold a pair of edges in to the center line.

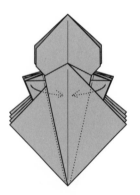

50. Valley-fold the next pair of edges.

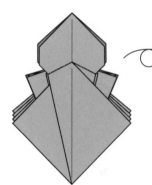

51. Turn the model over.

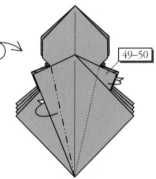

52. Repeat steps 49–50 on this side.

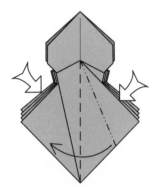

53. Squash-fold one layer in front and behind.

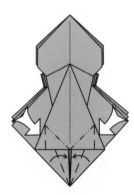

54. Reverse-fold the edges. Repeat behind.

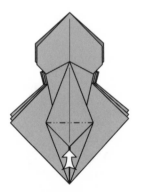

55. Sink the point. Do not repeat behind.

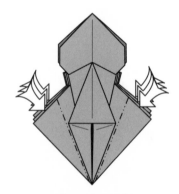

56. Reverse-fold six edges.

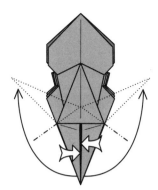

57. Reverse-fold two points.

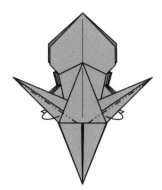

58. Mountain-fold the edge underneath.

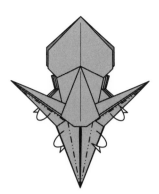

59. Mountain-fold the two edges on each side (they are linked together).

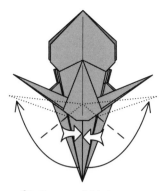

60. Reverse-fold the next pair of points upward.

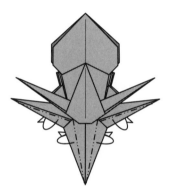

61. Mountain-fold two edges on each side.

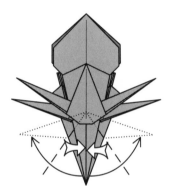

62. Reverse-fold two more points.

63. Mountain-fold two edges.

64. Valley-fold two edges.

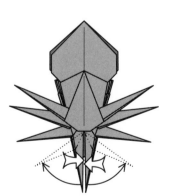

65. Reverse-fold the two remaining points.

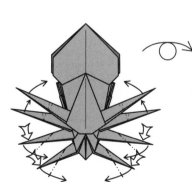

66. Reverse-fold the four lower legs. Crimp the four upper legs. Turn the model over.

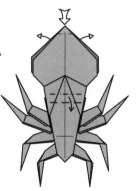

67. Sink the top slightly and puff it out.

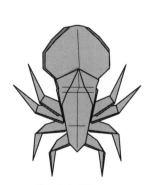

68. Orb Weaver.

◆ Tarantula ◆

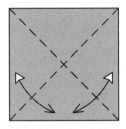

1. Fold and unfold along the diagonals.

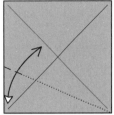

2. Fold and unfold along an angle bisector. Make the crease sharp only where it hits the edge.

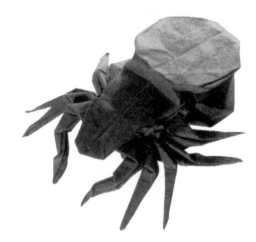

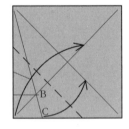

3. Fold the lower left corner up to point A and unfold. Make the crease sharp only as far as the diagonal.

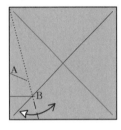

4. Fold a crease from the upper left corner through point B. Make the crease sharp only where it hits the bottom edge.

The Tarantula, like the Orb Weaver, is a spider, not an insect. Like all spiders, it has eight legs, but the male has two appendages, called pedipalps, that resemble a fifth pair of legs. They are actually part of the tarantula's mouth. Because of their size (up to 4 inches in legspan), they are often thought to be dangerous. However, the bite of a North American tarantula is actually no worse than a bee sting. They tend to be docile, and make good pets, with the males living 2 to 3 years and the larger females living up to 20.

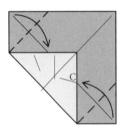

5. Fold the corner up so that it lies on one diagonal crease and point C lies on the other.

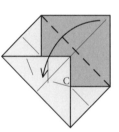

6. Fold the corners in.

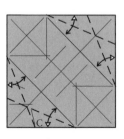

7. Fold the top right corner down.

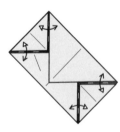

8. Fold and unfold.

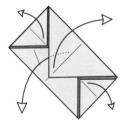

9. Unfold all four corners.

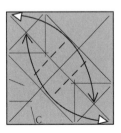

10. Fold and unfold.

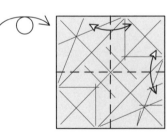

11. Fold and unfold. If you were accurate in steps 1–5, one of the creases will hit point C. Turn the paper over.

12. Fold and unfold.

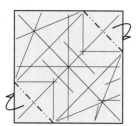 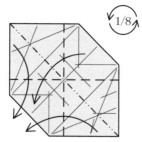 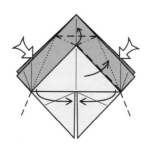 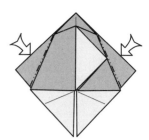

13. Fold two corners behind on existing creases.

14. Fold a Preliminary Fold. Rotate the model 1/8 turn counterclockwise.

15. Squeeze in the sizes and swing the resulting white flap over to the right.

16. Repeat behind.

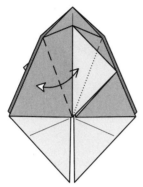 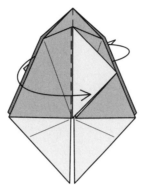 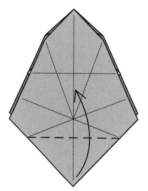

17. Fold and unfold on both the left and right. Repeat behind.

18. Fold one layer to the right in front and one to the left behind.

19. Valley-fold the corner upward. Repeat behind.

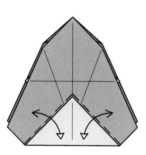 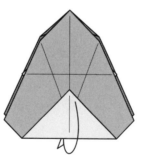 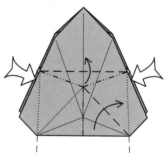

20. Fold and unfold through a single layer of paper. Repeat behind.

21. Fold the corner underneath. Repeat behind.

22. Squeeze the sides in and swing the middle bottom layers over to the right. Repeat behind.

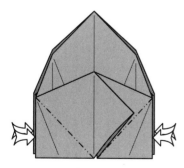 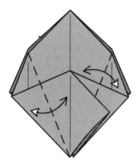 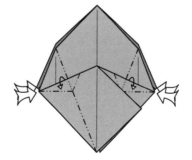 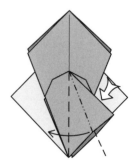

23. Reverse-fold the sides. Repeat behind.

24. Fold and unfold. Repeat on the right and on both sides behind.

25. Open-sink the four corners. You will have to open out a pleat as shown to complete the sink.

26. Squash-fold the flap. Repeat behind.

Tarantula 25

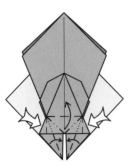 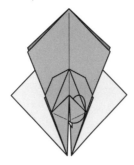 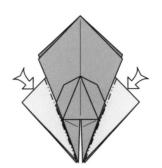 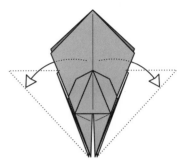

27. Petal-fold the edge. Repeat behind.

28. Tuck the corner underneath. Repeat behind.

29. Reverse-fold the edges.

30. Unwrap the white layers from each side.

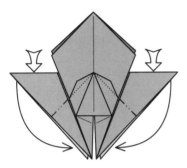 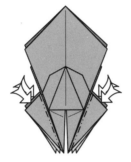 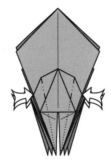

31. Reverse-fold the corners downward.

32. Reverse-fold four edges. There will be a total of ten points at the bottom.

33. Open-sink the corners. Repeat behind.

34. Fold the point down. Repeat behind.

35. Closed-sink the point up inside the model. Do not repeat behind.

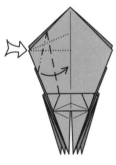 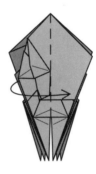 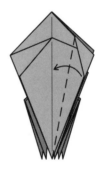 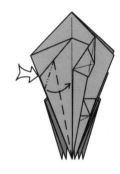

36. Spread-sink the corner, preserving the pleat that runs to its tip (indicated by the x-ray line). The result will be a shallow pyramid that does not lie flat.

37. Pinch the tip of the shallow pyramid and flatten it over to the left.

38. Fold a layer to the right.

39. Fold the layer to the center.

40. Spread-sink the left corner and flatten completely.

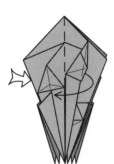 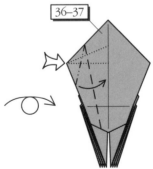

41. Fold the layer back to the left.

42. Repeat steps 36–41 on the right.

43. All ten bottom points are now shown. Turn the model over.

36–37

44. Repeat steps 36–37 on the left.

45. Fold the flap back to the left.

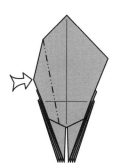 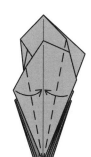 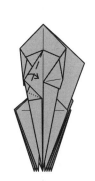 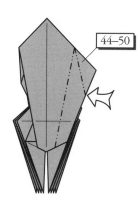

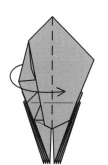

46. Closed-sink the corner on the crease you just made.

47. Fold one layer to the right.

48. Fold the edges in to the center line.

49. Fold down the corner. The x-ray line indicates hidden thicknesses of paper.

50. Fold a layer back to the left.

51. Repeat steps 44–50 on the right.

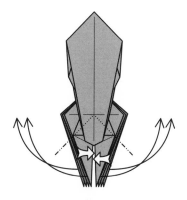 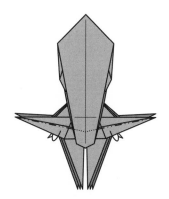 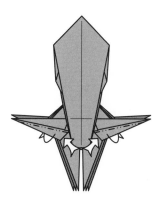 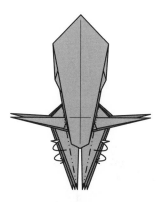

52. Reverse-fold two points in front and two behind.

53. Mountain-fold the near edge. Repeat behind.

54. Mountain-fold the next edge, reverse-folding at the base of each point. Repeat behind.

55. Mountain-fold the near edges. Repeat behind.

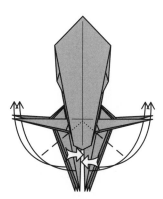 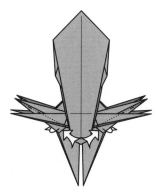 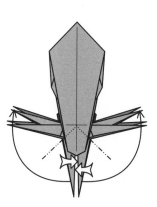

56. Reverse-fold a pair of points upward to lie slightly above the near pair. Repeat behind (leaving the middle pair at the bottom).

57. Mountain-fold the edges, reverse-folding at their base. Repeat behind.

58. Mountain-fold the edges. Repeat behind.

59. Reverse-fold the remaining pair of points up to line up with the two upper pairs.

Tarantula 27

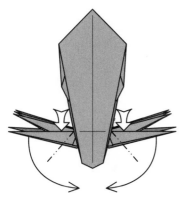

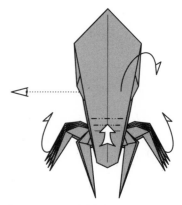

60. Reverse-fold the near pair of points downward sharply.

61. Reverse-fold the remaining four pairs of points downward at a somewhat lesser angle.

62. Mountain-fold the thick layers just above the legs; don't make the creases sharp, but work all of the layers into a curve. At the same time, swing the rearmost pair of legs behind and upward and fan the legs evenly. (The stylized eye on the left indicates that the next step will be shown from this vantage point.)

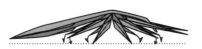

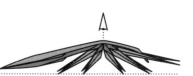

63. Side view. Adjust the position of the feet (by adjusting the reverse folds in the legs) so that they all touch the ground together. Leave the two right points (the pedipalps) standing out.

64. Like this. The next view is again of the top.

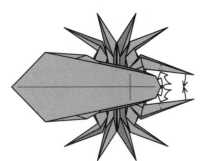

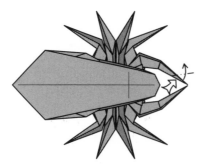

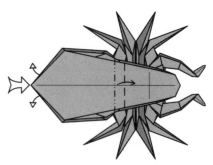

65. Crimp the pedipalps.

66. Squash-fold the tip of each pedipalp (only the upper one is shown here).

67. Crimp the body symmetrically and push in the left point (the abdomen).

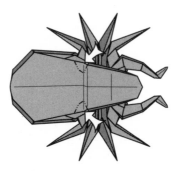

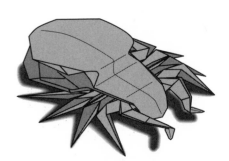

68. Like this.

69. Reverse-fold the corners. Repeat on the bottom.

70. Tarantula.

◆ Tick ◆

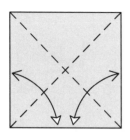

1. Fold and unfold along the diagonals.

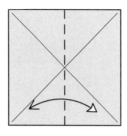

2. Fold and unfold from side to side.

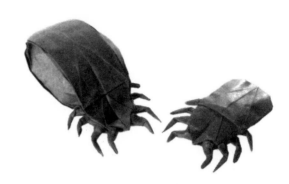

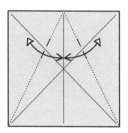

3. Fold and unfold, making the crease sharp only where it crosses the diagonal.

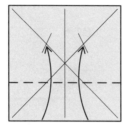

4. Fold the bottom edge up to touch the intersections of the creases you just made with the diagonals.

Although the Tick may appear at first to be an insect, a close examination reveals that it has eight legs, rather than six. It is actually more closely related to spiders and scorpions. Ticks range in size from no larger than the period at the end of this sentence up to over 5 mm long. All ticks are parasites, attaching themselves to a host and sucking a meal of blood. Although the quantity of blood removed is insignificant, ticks transmit a number of diseases to humans, including Rocky Mountain Spotted Fever (which, despite its name, is actually more common east of the Mississippi River) and Lyme disease.

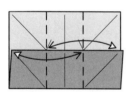

5. Fold and unfold.

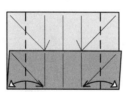

6. Fold and unfold.

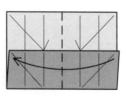

7. Fold the paper in half.

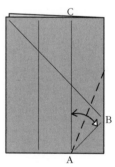

8. Fold crease AB to lie along AC and unfold.

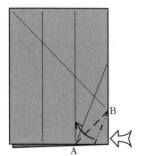

9. Squash-fold the lower right corner along crease AB.

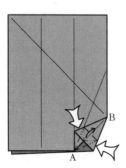

10. Petal-fold the corner.

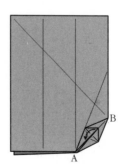

11. Fold the corner down.

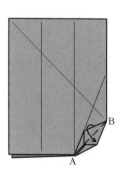

12. Fold one flap downward.

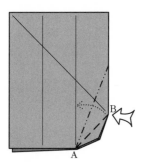 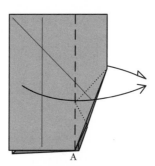 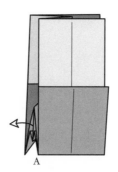 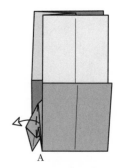

13. Reverse-fold corner B in and out using existing creases.

14. Fold one layer to the right in front and behind, using existing creases.

15. Unsink a single layer of paper.

16. Unsink a second layer of paper.

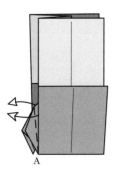 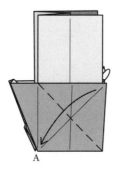 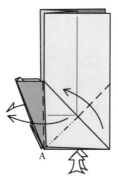 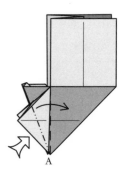

17. Pull out two layers of paper simultaneously.

18. Fold a corner down to point A in front. Repeat behind.

19. Squash-fold an edge. Repeat behind.

20. Squash-fold an edge.

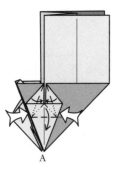 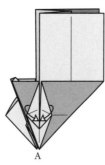 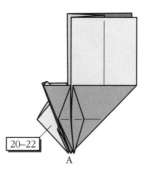 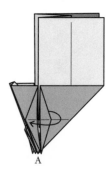

21. Petal-fold.

22. Wrap a single layer from back to front on each side, thereby freeing a corner at point A.

23. Repeat steps 20–22 behind.

24. Fold one layer to the left.

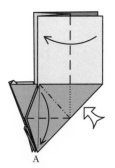 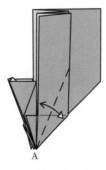 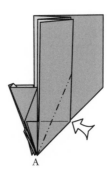 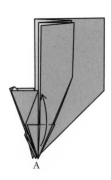

25. Squash-fold an edge.

26. Fold and unfold.

27. Sink the corner.

28. Fold up one corner.

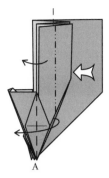

29. Spread-sink the edge.

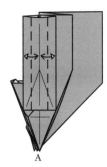

30. Fold the sides in to the center and unfold.

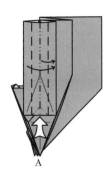

31. Simultaneously pleat a single layer of paper and sink its bottom edge upward.

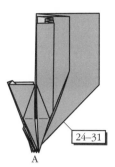

32. Repeat steps 24–31 behind.

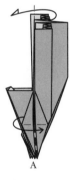

33. Fold one layer to the right in front and fold a group of pleats to the left behind.

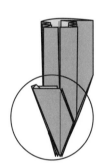

34. Steps 35–45 will focus on the lower part of the model.

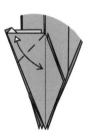

35. Fold and unfold along the angle bisector.

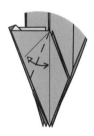

36. Fold and unfold along the angle bisector.

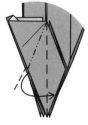

37. Open out the pocket; the model will not lie flat.

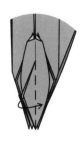

38. Fold one layer to the right.

39. Put your finger inside the pocket and push out point D.

40. Fold point D down, pinch the excess paper in half and swing it over to the right.

41. Squash-fold the flap.

42. Petal-fold.

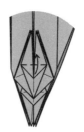

43. Fold up the corner.

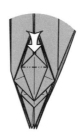

44. Sink the corner inside.

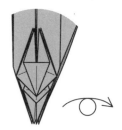

45. Turn the model over.

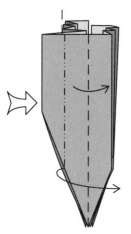

46. Spread-sink the long edge.

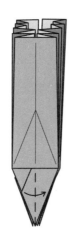

47. Fold one layer to the right.

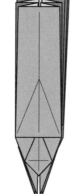

48. Turn the model back over.

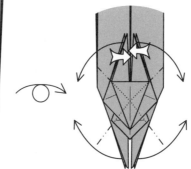

49. Reverse-fold the two near points on the top. Reverse-fold the two inside points on the bottom.

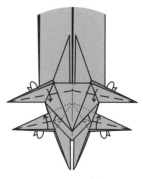

50. Narrow all four points with mountain and valley folds.

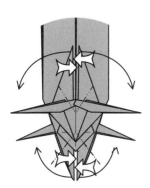

51. Reverse-fold four more points, spreading the layers evenly.

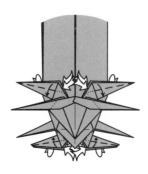

52. Narrow the remaining four points.

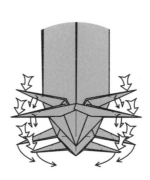

53. Outside-reverse-fold the upper four legs; inside-reverse-fold the lower four legs.

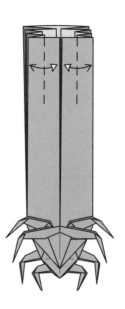

54. Crease lightly through a single layer.

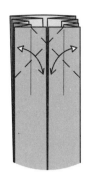

55. Crease lightly through all layers.

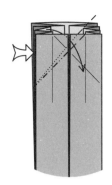

56. Reverse-fold the second edge from the top, using the creases you just made.

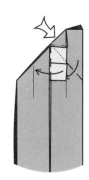

57. Squash-fold the edge and swing the white layers over to the left.

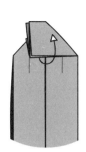

58. Wrap two layers to the front.

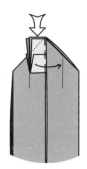

59. Squash-fold the middle edge. The result should be symmetric from left to right.

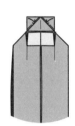

60. Tuck the corners into the pockets.

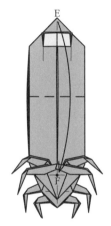

61. There are two ways to finish this model. To make the Sated Tick, skip to step 66 and follow steps 66–69. To make the Hungry Tick, fold point E down to point F and continue with steps 62–65.

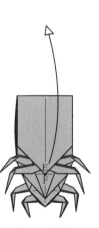

62. Unfold.

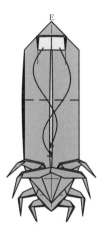

63. Refold point E down, tucking the two small flaps underneath the layers along the midline of the model.

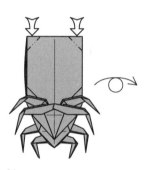

64. Reverse-fold the corners and turn the model over.

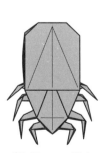

65. Hungry Tick.

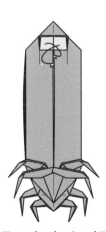

66. To make the Sated Tick, fold up through step 60, then skip to this step. Wrap both small flaps around and tuck them inside the model.

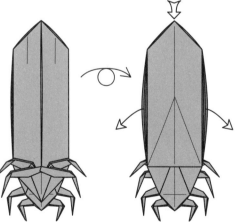

67. Turn the model over.

68. Grasp the third edge back on each side and pull them out to the side. Put your finger inside the model from the bottom and round it.

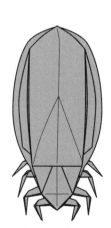

69. Sated Tick.

◆ Ant ◆

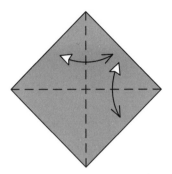

1. Begin with the colored side up. Fold and unfold.

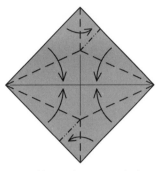

2. Fold a Fish Base with the points going in opposite directions.

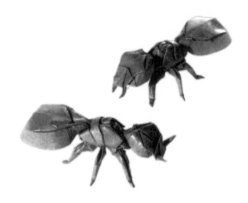

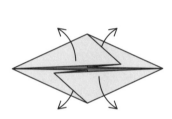

3. Unfold to step 1.

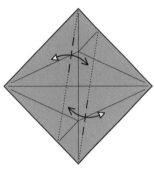

4. Fold and unfold. Make the crease sharp only where it crosses the creases of the Fish Base.

The Ant is one of a large family of insects characterized by wingless bodies with well-defined divisions between the head, thorax, and abdomen. Most ants live in large colonies containing thousands of workers. While the ants in most colonies are the offspring of a single queen, some fire ants of the American Southeast have evolved into "supercolonies" that consist of many interlinked colonies and can spread over as much as an acre of land.

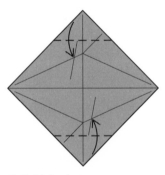

5. Fold the bottom corner up so that its right edge hits the intersection of the two creases; repeat above.

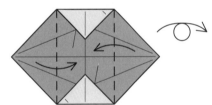

6. Fold the sides in and turn the model over.

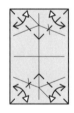

7. Fold and unfold.

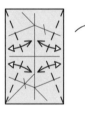

8. Fold and unfold; then turn the model back over.

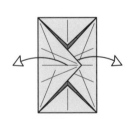

9. Unfold the sides.

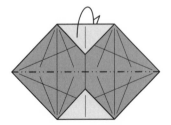

10. Mountain-fold the model in half.

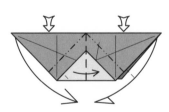

11. Squash-fold the left side in front and the right side behind.

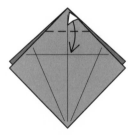

12. Fold and unfold.

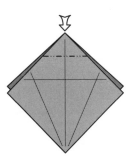

13. Open-sink the point using the crease you just made.

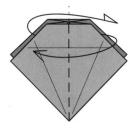

14. Fold one flap to the left in front and one to the right behind.

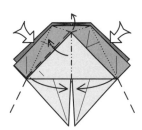

15. Bring the sides of the white triangle together and swing it over to the left.

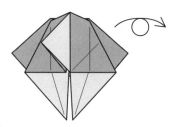

16. Turn the model over.

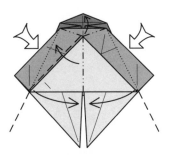

17. Repeat step 15 on this side.

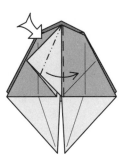

18. Squash-fold the white flap.

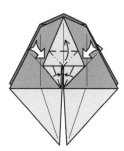

19. Petal-fold the edge.

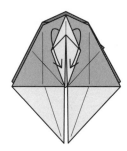

20. Unwrap a single layer of paper.

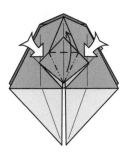

21. Petal-fold the point upward.

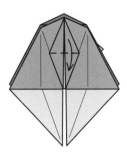

22. Fold the flap down.

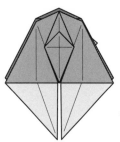

23. Turn the model over.

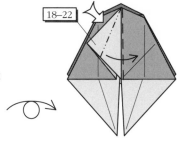

24. Repeat steps 18–22 on this side.

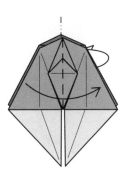

25. Fold one layer to the right in front and one to the left behind.

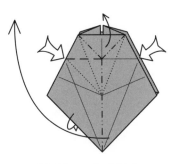

26. Mountain-fold the near bottom layer in half and swing it up to the left.

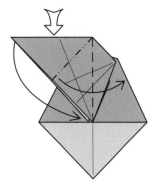

27. Squash-fold the flap.

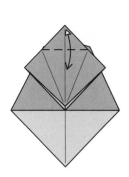

28. Fold and unfold.

Ant 35

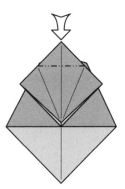

29. Open-sink the corner on the crease you just made.

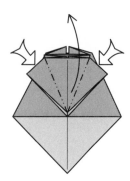

30. Petal-fold the flap.

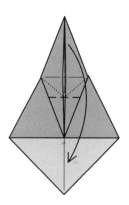

31. Stretch the top point down as far as possible.

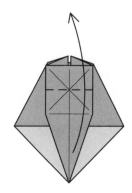

32. Fold the point back up.

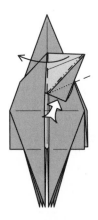

33. Turn the model over.

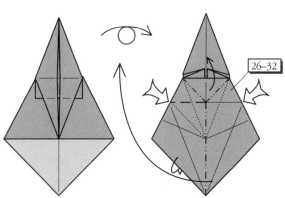

34. Repeat steps 26–32 on this side.

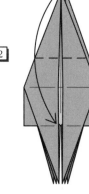

35. Fold one point down to the horizontal creases.

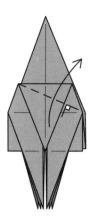

36. Fold the point up to the right.

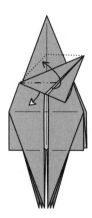

37. Pull out some loose paper.

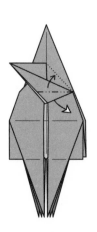

38. Squash-fold the flap over to the left.

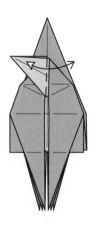

39. Pull out some loose paper.

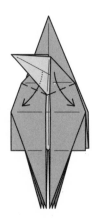

40. Fold the white flap back and forth to each side.

41. Open out the white flap and flatten it.

42. Mountain-fold the bottom corner in half and swing it over to the right.

43. Squash-fold the point over to the left.

44. Fold the point over to the right.

45. Fold the top flap down.

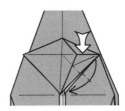

46. Reverse-fold the point.

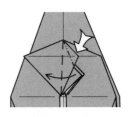

47. Spread-sink the corner, spreading the layers symmetrically.

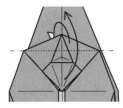

48. Swing the group of three points upward and pivot the top of the flap behind.

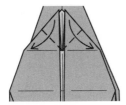

49. Fold two corners down to the sides.

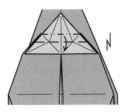

50. Pleat the flap. Note the reference points for each crease.

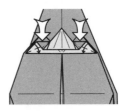

51. Squash-fold the edges.

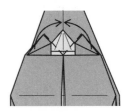

52. Fold the two corners up.

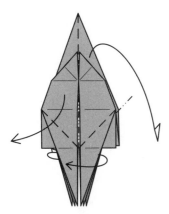

53. Mountain-fold the near flap in half, swinging it down to the left. Valley-fold the far flap in half, swinging it down to the right. Spread the layers at the bottom symmetrically.

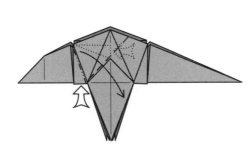

54. Petal-fold the upper corner downward.

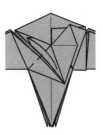

55. Fold the flap back upward.

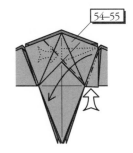

54–55

56. Repeat steps 54–55 on the right.

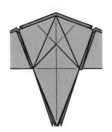

57. Turn the model over.

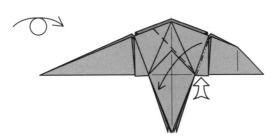

58. Petal-fold the right upper corner downward. (The inside layer is already petal-folded.)

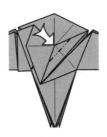

59. Sink the corner.

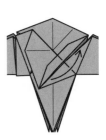

60. Fold the flap back up.

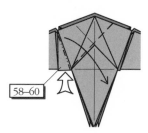

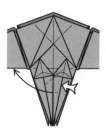

61. Repeat steps 58–60 on the left.

62. Fold two edges in to the center line.

63. Spread-sink the two edges.

64. Reverse-fold the flap.

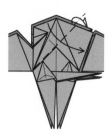

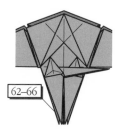

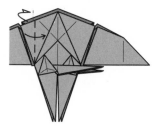

65. Swing the flap to the right, mountain-folding it in half. The flap will not go all the way to the right, and the flap will not lie flat.

66. Reverse-fold the left side of the base of the flap, wrap one layer of paper from the inside to the outside, and flatten the model completely.

67. Repeat steps 62–66 behind.

68. Fold one edge to the right to meet a folded edge. Repeat behind.

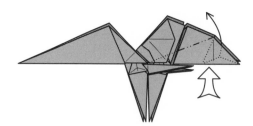

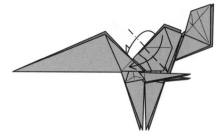

69. Simultaneously fold the near and far layers down and to the right, distributing the paper evenly. Flatten firmly.

70. Reverse-fold the right flap upward.

71. Simultaneously fold the near and far layers down and to the left, distributing the paper evenly. Flatten firmly.

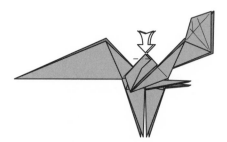

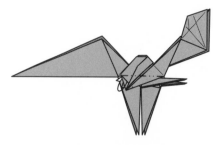

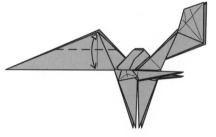

72. Reverse-fold the two top corners.

73. Mountain-fold the corner underneath and tuck it inside the pocket.

74. Fold and unfold; repeat behind.

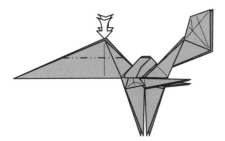

75. Closed-sink the corner. Repeat behind.

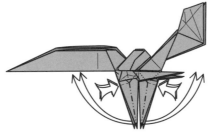

76. Double-rabbit-ear four points, two to the left and two to the right. Spread the layers symmetrically.

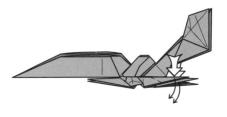

77. Outside-reverse-fold the middle pair of legs.

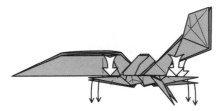

78. Inside-reverse-fold the other four legs.

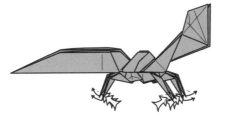

79. Reverse-fold the front and back legs to make feet. Crimp the middle pair of legs to make feet.

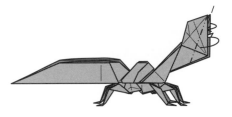

80. Mountain-fold the edges of the head inside.

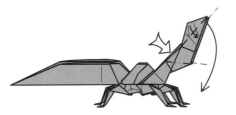

81. Squash-fold the head.

82. Reverse-fold two points to form antennae. (You can leave them pointing downward to make jaws if you prefer.)

83. Pinch the antennae in half.

84. Wrap two layers of the head to the rear. Round and shape the head from the underside. Push up the inner layer of the abdomen to make it three-dimensional.

85. Reverse-fold the abdomen downward, keeping it three-dimensional.

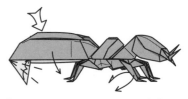

86. Fold the point under the abdomen over and over and tuck it up inside the abdomen. Round the abdomen. Spread the legs apart.

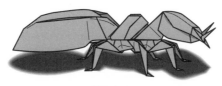

87. Ant.

◆ Butterfly ◆

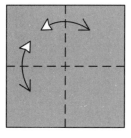

1. Begin with the colored side up. Crease the paper in half and turn the paper over.

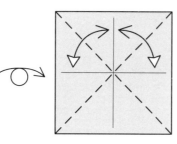

2. Crease the diagonals.

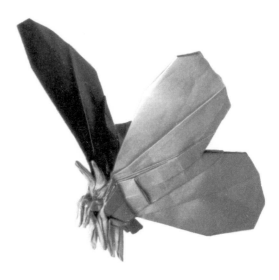

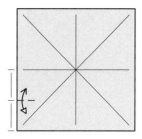

3. Pinch near the left edge.

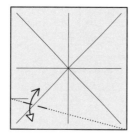

4. Fold and unfold, but only make the crease sharp where it crosses the diagonal.

Butterflies and moths are known for their large, often brightly colored wings. Butterflies are distinguished from moths by their hours; butterflies fly only during the day, while moths are active primarily at night. In addition, butterflies hold their wings vertically while resting; moths hold them flat over their back.

5. Fold the right edge to the intersection of the last crease with the diagonal and unfold. Turn the paper over.

6. Fold the left edge to the crease you just made and unfold.

7. Use the intersections between the crease from the last step and the diagonals to place these three creases. Turn the paper over.

8. Use the intersections between the crease from step 5 and the diagonals to place these creases.

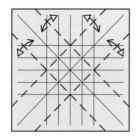

9. Fold and unfold.

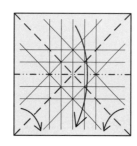

10. Fold a Waterbomb Base.

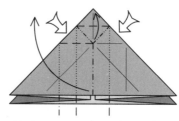

11. Squeeze in the sides and swing the middle of the bottom edge up to the left.

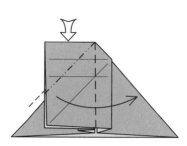

12. Squash-fold.

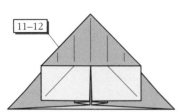

13. Repeat steps 11–12 behind.

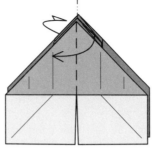

14. Fold two layers to the left in front (one wide, one narrow) and two to the right behind.

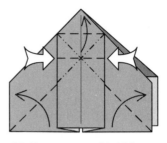

15. Repeat steps 11–12 here; they must be performed simultaneously.

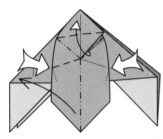

16. Turn the model over.

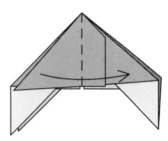

17. Repeat step 15 here.

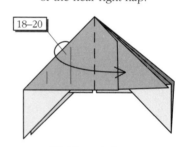

18. Open out the top of the near right flap.

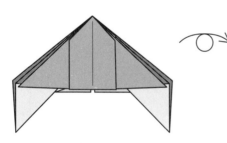

19. The opened flap forms a shallow, downward-pointing cone; closed-sink the top of the cone upward (i.e., push from inside the model) and squeeze the sides of the flap together. Swing it over to the left.

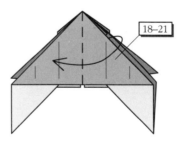

20. Fold two flaps (the large triangular flap and the narrow trapezoid behind it) to the right.

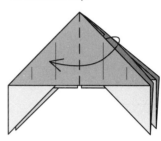

21. Repeat steps 18–20 on the left.

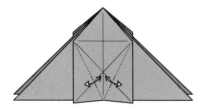

22. Turn the model over.

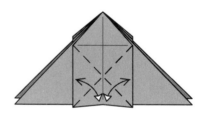

23. Repeat steps 18–21 on this side.

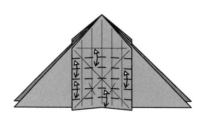

24. Crease through one layer.

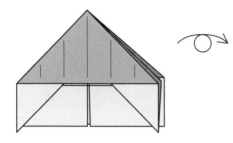

25. Fold and unfold, but make each crease sharp only where it crosses the diagonal.

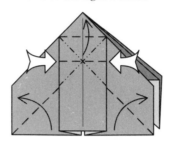

26. Use this intersection as a guide to divide each flap into thirds.

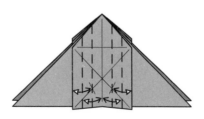

27. Fold and unfold.

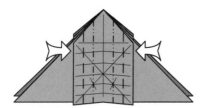

28. Reverse-fold the edges in and out on the existing creases. Be careful that you do not trap any layers at the top (see next step).

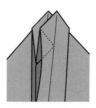

29. Enlarged view. This is probably the hardest step in the entire model (and you get to do it six more times!).

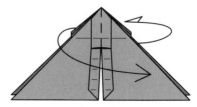

30. Stretch the bottom points up and out to the sides, pleating the middle layers horizontally on existing creases.

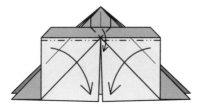

31. Reverse-fold the two edges down to the bottom again.

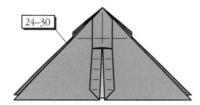

32. Repeat steps 24–30 behind.

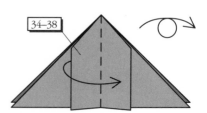

33. Fold one large and one small flap to the right in front; repeat on the left behind.

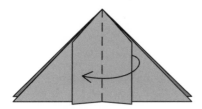

34. The model is now symmetric. Fold one narrow flap from right to left.

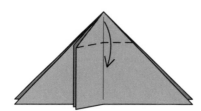

35. Fold one layer down.

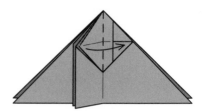

36. Fold one layer to the right.

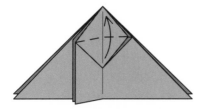

37. Fold one layer up.

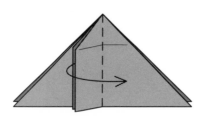

38. Fold one layer to the right.

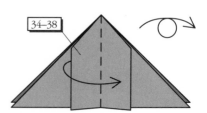

39. Repeat steps 34–38 on the left side. Turn the model over.

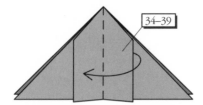

40. Repeat steps 34–39 on this side.

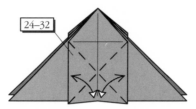

41. Repeat steps 24–32.

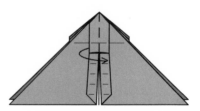

42. Fold the narrow flap to the right.

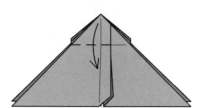 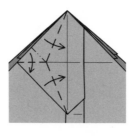 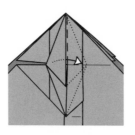 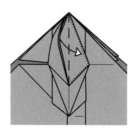

43. Fold one flap down.

44. Fold a rabbit ear.

45. Pull out a single layer of paper.

46. Pull a single edge out from the inside.

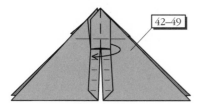 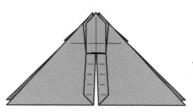 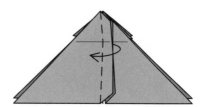

47. Pull out the next edge.

48. Fold the point back up.

49. Fold one flap back to the left.

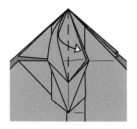 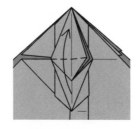 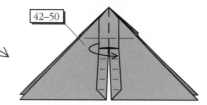

50. Repeat steps 42–49 on the right.

51. Turn the model over.

52. Repeat steps 42–50 on this side.

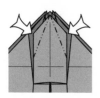 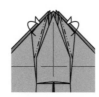 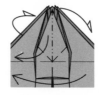 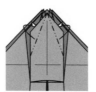 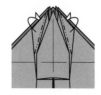

53. Sink the frontmost two corners; do not repeat behind.

54. Mountain-fold the next two corners. Repeat behind on the corresponding pair of corners.

55. Fold three flaps (one large, two narrow) to the left in front; repeat behind. As you do this, reverse-fold the front point down and to the left; reverse-fold the corresponding point behind down and to the right.

56. Mountain-fold the frontmost two corners into the pockets just behind them. Repeat behind.

57. Mountain-fold the next two corners. Repeat behind on the corresponding pair of corners.

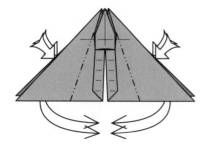 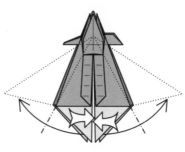 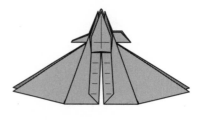

58. Reverse-fold the four large points downward.

59. Reverse-fold the four points back outward. Note where the folded edge intersects the rest of the model.

60. Like this. Now we will work on the top of the model.

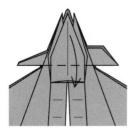

61. Fold down the cluster of three points. (You don't need to fold it all the way down, although it is shown that way in the next step for clarity.)

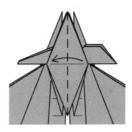

62. Fold one layer to the left.

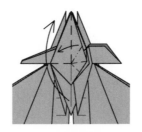

63. Fold the remaining layer to the left and simultaneously fold the cluster of points back up.

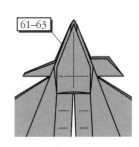

64. Repeat steps 61–63 behind.

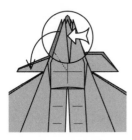

65. Reverse-fold the middle point downward to lie alongside the left point.

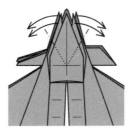

66. Reverse-fold two points each to the left and right.

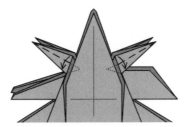

67. Narrow the legs with valley folds (reverse-fold where the leg meets the body).

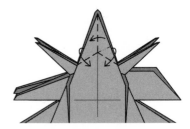

68. Fold a rabbit ear from the top point; repeat behind.

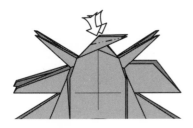

69. Sink the edge to narrow the leg.

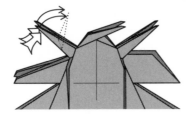

70. Reverse-fold the legs upward.

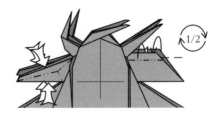

71. Pinch the two points on the left (the antennae) and narrow the point on the right (the abdomen). Then rotate the model 1/2 turn.

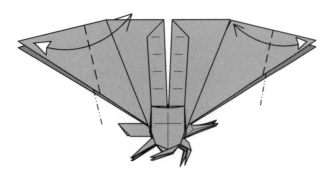

72. Fold and unfold. Repeat behind.

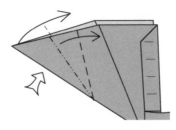

73. Detail of wing. Squash-fold the edge on the crease you just made.

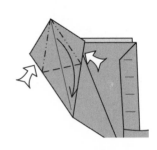

74. Petal-fold.

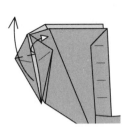 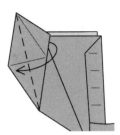 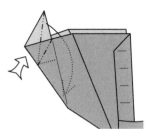 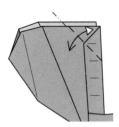 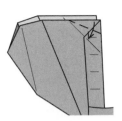

75. Fold the point back up and undo half of the petal fold.

76. Fold in half.

77. Reverse-fold the point to the inside, locking the wingtip together.

78. Fold and unfold. Repeat on the far side of the wing.

79. Fold the top edge to the crease you just made. Do not repeat on the far side.

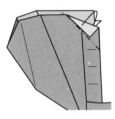 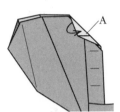

80. Mountain-fold the near flap behind.

81. Valley-fold the corner of the far layer of the wing over the near layer.

82. Fold a rabbit ear.

83. Tuck the white flap into the pleat on the near one; flap A goes into a tiny pocket inside the pleat.

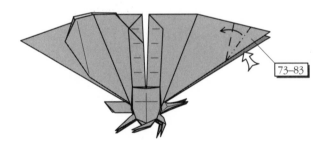

73–83

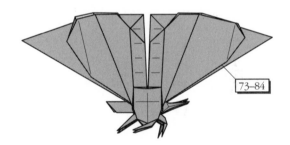

73–84

84. Repeat steps 73–83 on the right, using the existing crease as a reference.

85. Repeat steps 73–84 behind.

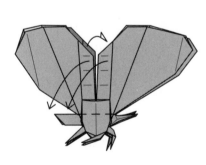 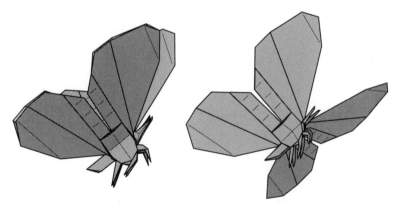

86. Fold down the wings.

87. Butterfly. If you would like a challenge, you can make a butterfly with a more slender body by dividing the square region of the paper into fifths rather than thirds in steps 25–41.

◆ Scarab Beetle ◆

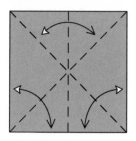

1. Fold and unfold.

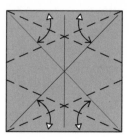

2. Fold and unfold.

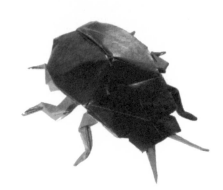

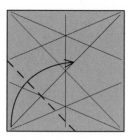

3. Fold one corner up.

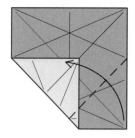

4. Fold the other corner up.

Scarabs are stout, round beetles, famous in history and lore. One group of scarabs includes dung beetles, which live in pastures and roll balls of dung to their burrows. In ancient Egypt, the related Sacred Scarab beetle was associated with rebirth and scarab beetles were buried within the pharaohs' tombs. Many scarabs are shiny and metallic, and one, the Goldsmith beetle, is the "Gold-Bug" of the famous Edgar Allan Poe short story.

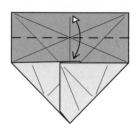

5. Fold and unfold.

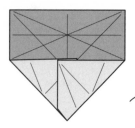

6. Turn the paper over.

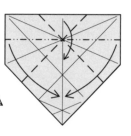

7. Fold the top like a Waterbomb Base.

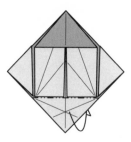

8. Fold the bottom corner behind.

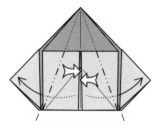

9. Reverse-fold two edges on existing creases.

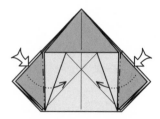

10. Reverse-fold two edges inward.

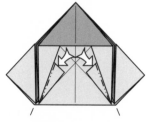

11. Reverse-fold two edges.

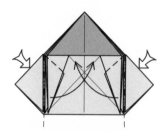

12. Squash-fold the two edges upward so that they overlap.

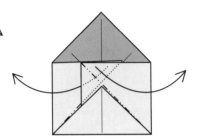
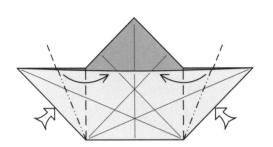

13. Turn the paper over.

14. Pull two corners out as far as possible.

15. Squash-fold two points.

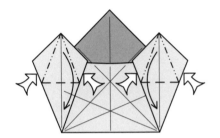
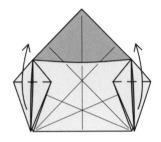
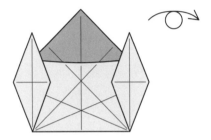

16. Petal-fold the two corners.

17. Fold the two points back upward.

18. Turn the paper over.

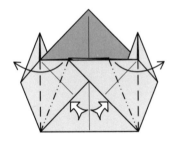
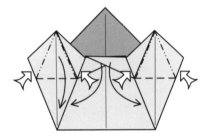
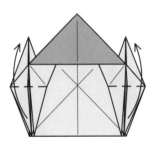

19. Squash-fold the edges.

20. Petal-fold the two corners. The two crossing points in the middle swing down along with the petal folds.

21. Fold two points up on each side.

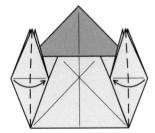
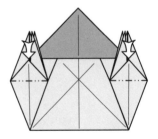
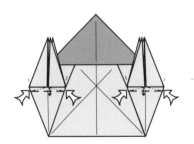

22. Fold one layer toward the center on each side.

23. Sink the point on each side.

24. Petal-fold the edge slightly.

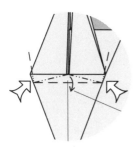

25. Close-up view.

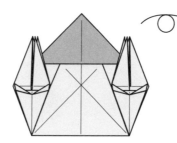 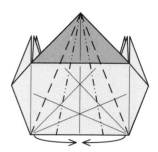

26. Turn the model over.

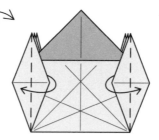

27. Fold one layer to the outside on both left and right.

28. Pleat the sides in.

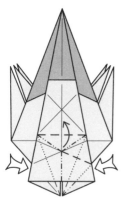

29. Squeeze the sides in and swing the excess paper over to the right.

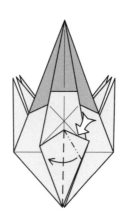

30. Squash-fold.

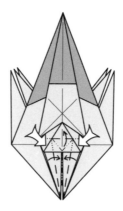

31. Petal-fold the edge.

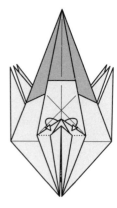

32. Bring two layers to the front. This is most easily done simultaneously with step 33. It is broken into two steps here to show how the layers are stacked.

33. Bring two layers to the front on each side.

34. Bring two layers in front on the upper point and tuck them behind flap A, which is no longer trapped.

35. Valley-fold flap A down to the horizontal crease.

36. Valley-fold the raw edge upward.

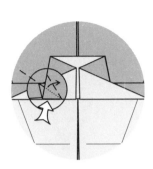

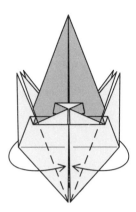

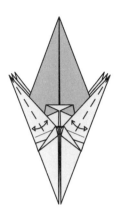

37. Squash-fold the hidden corner. Repeat on the right (not shown).

38. Fold all edges in toward the center line on both left and right.

39. Fold and unfold along the angle bisectors.

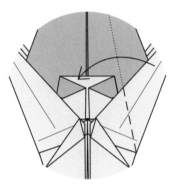

40. Fold the point over along a crease that is aligned with the hidden edges. A tiny gusset will form at the base.

41. Reverse-fold the white corner.

42. Mountain-fold the point behind, hooking it behind the layers indicated by the x-ray lines.

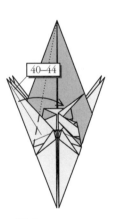

43. Swivel-fold the edge using the existing crease. This locks the antenna to the rest of the head.

44. This is optional, because it is difficult. Bring one layer of paper in front of the flap.

45. Repeat steps 40–44 on the left.

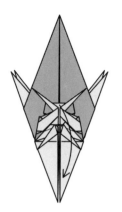 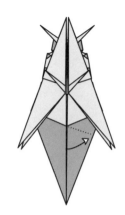 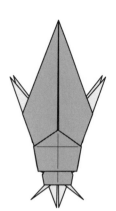 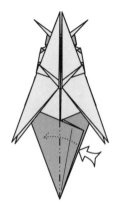

46. Fold the entire head assembly down.

47. Turn the model over from top to bottom.

48. Pull a single layer of paper out (it may have already come out during previous steps).

49. Reverse-fold the edge to one side.

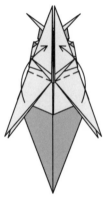 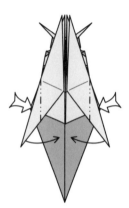 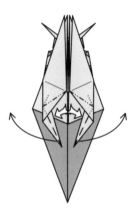 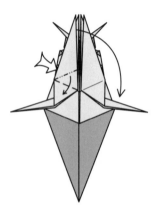

50. Fold two points up.

51. Reverse-fold two points along vertical creases.

52. Simultaneously reverse-fold and narrow the points, somewhat like a petal fold.

53. Squash-fold the flap symmetrically.

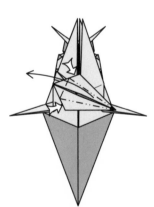 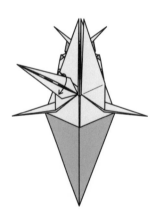 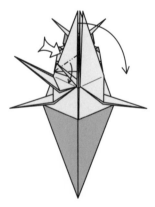

54. Petal-fold.

55. Fold the flap in half.

56. Squash-fold the thick point, spreading the layers as evenly as you can, with the excess paper going downward.

57. Carefully petal-fold the thick point.

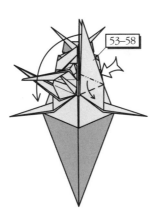

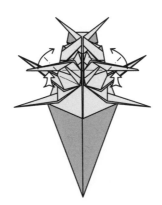

58. Fold the flap in half.

59. Repeat steps 53–58 on the right.

60. Reverse-fold the two thick points.

61. Reverse-fold the other four points.

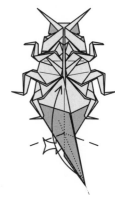

62. Reverse-fold all six feet.

63. Crease through all layers.

64. Pleat through all layers and push down the middle. The model will no longer lie flat.

65. Fold the thick point up while simultaneously mountain-folding its rear half along the crease from step 63.

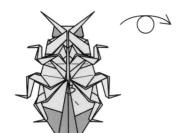

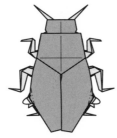

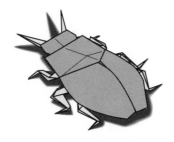

66. Tuck the tip of the thick point inside some of the pleats and turn the model over.

67. Mountain-fold the corners of the body and round it out.

68. Scarab Beetle.

Scarab Beetle 51

◆ Cicada ◆

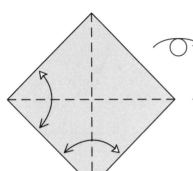

1. Fold and unfold. Turn the paper over.

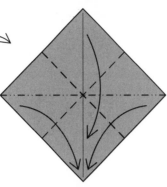

2. Fold a Preliminary Fold. (Yes, the colored side should be on the inside.)

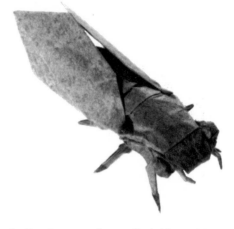

Although Cicadas are often called 13- or 17-year locusts, they are not true locusts (which are in the same family as grasshoppers and crickets). Most species of cicada spend anywhere from 1 to 17 years of their life underground as juvenile nymphs. In the fall, the nymph climbs out of the ground and clings to a nearby tree; its shell splits, and the adult cicada emerges, leaving behind an empty shell in the shape of the nymph. Adult cicadas have sound-producing organs beneath their abdomen. Their buzzing or chittering sound is surprisingly loud, and the tone and pattern is distinct for each species.

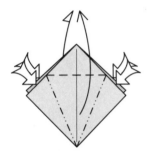

3. Petal-fold to make a Bird Base.

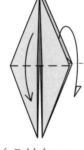

4. Fold the two upper flaps down.

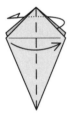

5. Fold one layer to the right in front and one to the left behind.

6. Fold and unfold in front and behind.

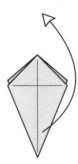

7. Unfold completely.

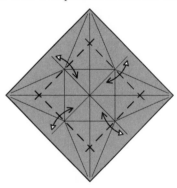

8. Fold and unfold, using the existing creases as a guide.

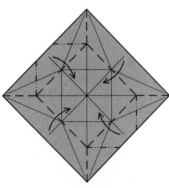

9. Fold four interlocked rabbit ears all the way around the square. Rotate 1/8 turn counterclockwise.

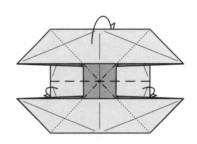

10. Fold a Waterbomb Base from the shape on existing creases.

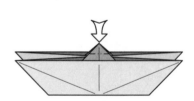

11. Closed-sink the top point halfway.

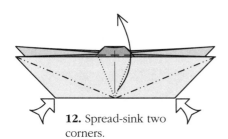

12. Spread-sink two corners.

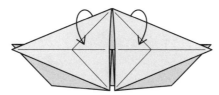

13. Wrap one raw edge from back to front.

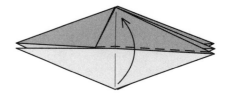

14. Turn the model over.

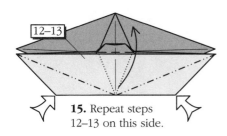

12–13

15. Repeat steps 12–13 on this side.

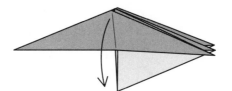

16. Fold one layer to the right.

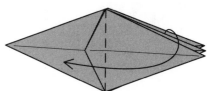

17. Fold one layer up.

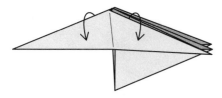
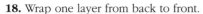

18. Wrap one layer from back to front.

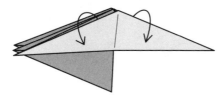

19. Fold the flap down.

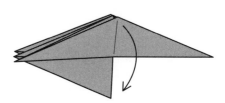

20. Fold two layers to the left.

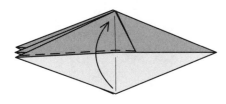

21. Fold one layer up.

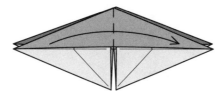

22. Wrap one layer to the front.

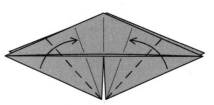

23. Fold one layer down.

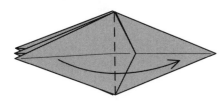

24. Fold one layer to the right.

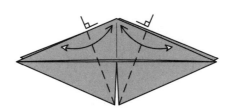

25. Fold and unfold through a single layer on each side.

26. Fold the lower edges up to the creases you just made.

Cicada 53

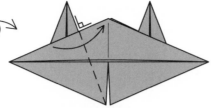

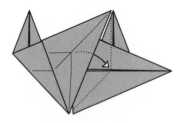

27. Turn the model over.

28. Fold one flap up to the right.

29. Pull out some loose paper.

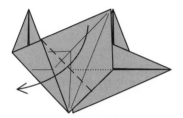

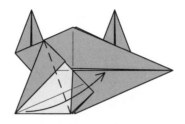

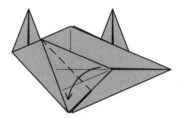

30. Fold the point back down to the left.

31. Fold the point back up to the left.

32. Fold the point back down to the left.

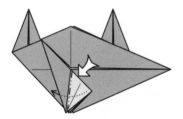

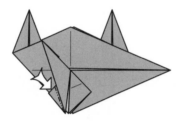

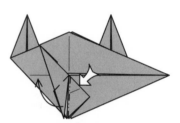

33. Reverse-fold the edge.

34. Reverse-fold the edge.

35. Squash-fold the edge, swinging two points up to the left.

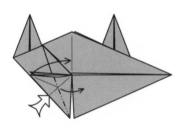

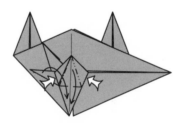

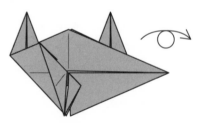

36. Squash-fold the edge upward.

37. Petal-fold.

38. Turn the model over.

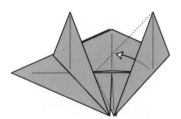

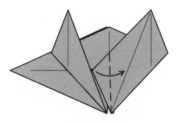

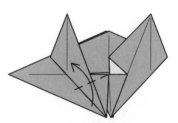

39. Pull out some loose paper.

40. Fold the flap over to the right.

41. Fold the bottom left point up out of the way. You needn't make the crease sharp.

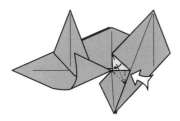

42. Reverse-fold the edge.

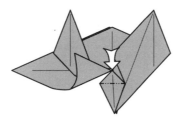

43. Sink the point.

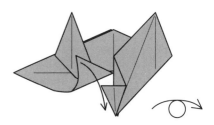

44. Fold the left point back down and turn the model over.

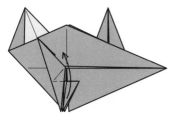

45. Fold two points upward.

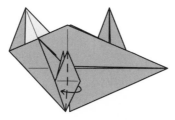

46. Fold the flap to the left as far as possible. Make sure the point at the bottom is sharp.

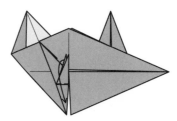

47. Fold two points down.

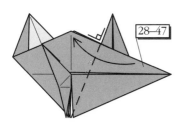

48. Repeat steps 28–47 on the right.

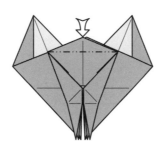

49. Open-sink the point.

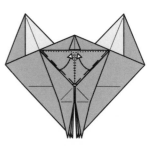

50. Pull the folded edge upward on each side.

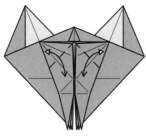

51. Fold and unfold along the angle bisectors.

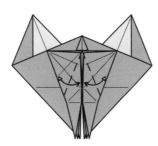

52. Fold and unfold along the angle bisectors.

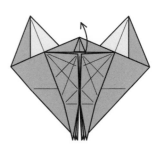

53. Pull out some loose paper.

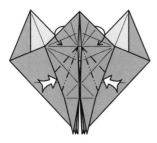

54. Crimp the edges in and out, spreading the layers symmetrically. The top of the model curves inward, and will no longer lie flat.

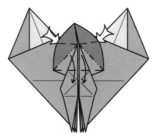

55. Pull the corners out from the inside of the hood formed in the last step.

56. Swing the excess paper over to one side.

57. Squash-fold the flap.

58. Petal-fold the edge.

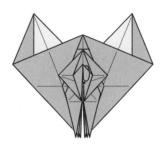

59. Tuck the point inside.

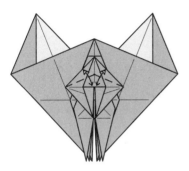

60. Fold and unfold through all layers.

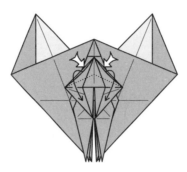

61. Pull one edge down and sink the edge behind it on each side. See succeeding steps for details.

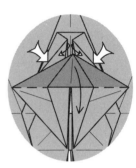

62. As you pull the edges down, you must pull some paper out of the vertical pleats.

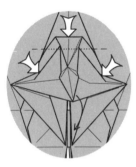

63. Continue pulling the point downward and roll some paper down from the top. Flatten completely.

64. Mountain-fold the edges of the two horizontal points behind, stretching them at their base.

65. The cut-away view of the right shows how far the base is stretched.

66. Sink the two edges and fold the excess paper over to the right.

67. Spread-sink the point symmetrically.

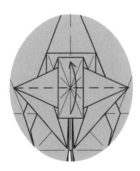

68. Fold the bottom half of the point upward.

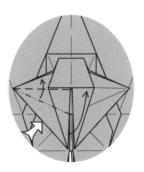

69. Squash-fold the point.

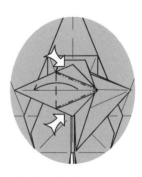

70. Petal-fold the point.

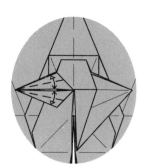

71. Fold the edges of the point in and unfold. These creases will make step 75 easier.

72. Fold the point to the right.

73. Fold one layer up.

74. Reverse-fold the point.

75. Narrow the point with mountain folds.

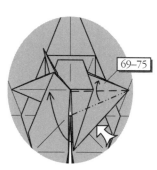

76. Repeat steps 69–75 on the right.

69–75

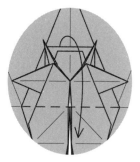

77. Fold the top 3 flaps downward as one; you needn't make the crease sharp.

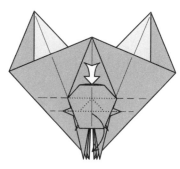

78. Stretch the flap down as far as possible. Flatten the model completely.

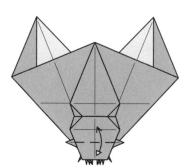

79. Fold one layer up and unfold.

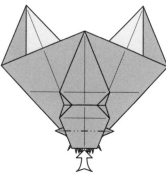

80. Closed-sink the point on the crease you just made.

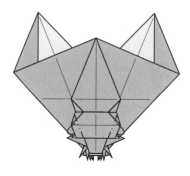

81. Mountain-fold the edges underneath. Wrap them around as many layers as possible.

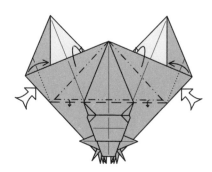

82. Pleat the top of the model. Simultaneously, squash-fold the sides inward and narrow the top of the point.

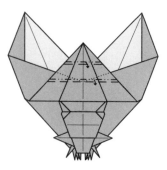

83. Pleat the top of the model twice more.

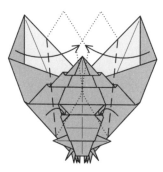

84. Fold the wings in toward the center so that they overlap slightly. Note where the lower portion of the wings tucks beneath some layers.

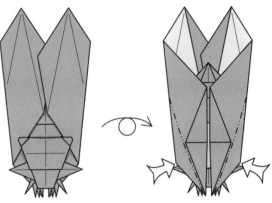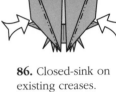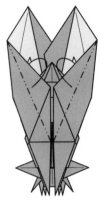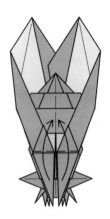

85. Turn the model over.

86. Closed-sink on existing creases.

87. Mountain-fold the edges underneath.

88. Fold two thick points upward.

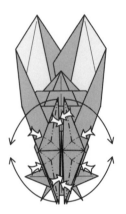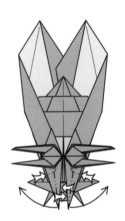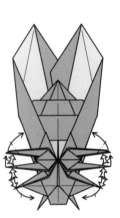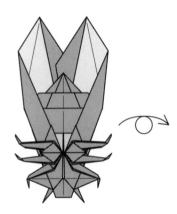

89. Double-rabbit-ear-fold four legs.

90. Double-rabbit-ear-fold the remaining two legs.

91. Reverse-fold feet onto all six legs.

92. Turn the model over.

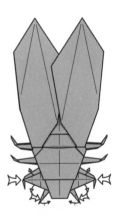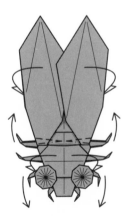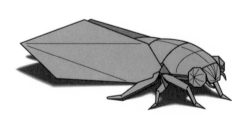

93. Squash-fold the eyes and reverse-fold the antennae. Round the body slightly.

94. Round the body. Crimp the body slightly so that the back is arched. Adjust the position of the legs and crimp them to have a natural appearance.

95. Cicada.

◆ Grasshopper ◆

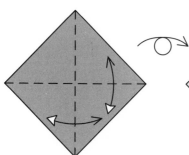

1. Fold and unfold along the diagonals. Turn the paper over.

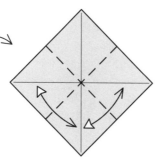

2. Fold and unfold along the sides.

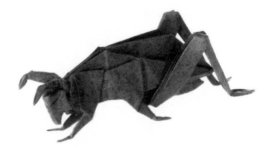

Grasshoppers are among the most recognizable of insects. Their long, strong rear legs give them the ability to jump many times their body length. Males of most species have special roughened regions on their legs or wings that they rub together to make a musical chirping or singing. Some grasshoppers periodically migrate in swarms that can number in the millions, devouring all plant life in their path. The most famous such swarm attacked the lands of the early Mormon settlers in Utah; the fields were saved by a second swarm, this one of birds, that swooped in and devoured the marauding insects.

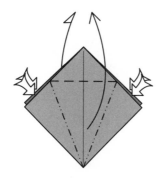

3. Fold a Preliminary Fold.

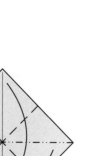

4. Petal-fold the front and back to make a Bird Base.

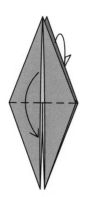

5. Fold one point down in front and one down behind.

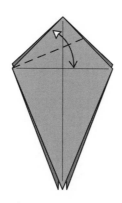

6. Fold and unfold.

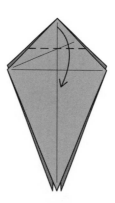

7. Fold the point down.

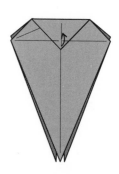

8. Fold the point up. The fold lines up with the crease behind the point.

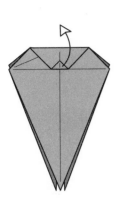

9. Unfold to step 7.

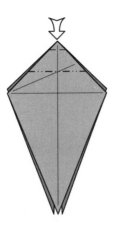

10. Sink in and out on the creases you just made.

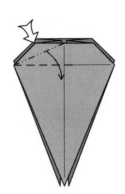

11. Spread-sink a single corner; the model will not lie flat.

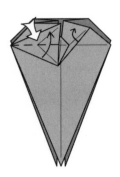

12. Close up the model.

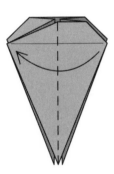

13. Fold one layer to the left.

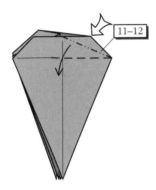

14. Repeat steps 11–12 on the right. (There should be three layers on the left.)

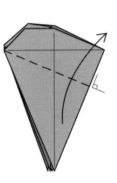

15. Fold one layer up to the right.

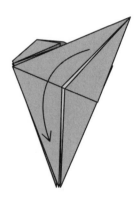

16. Unfold.

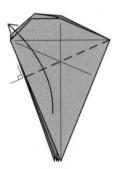

17. Fold the flap up to the left.

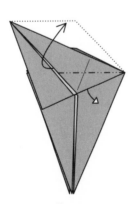

18. Pull out some loose paper.

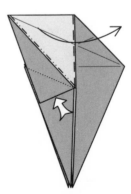

19. Squash-fold the point over to the right.

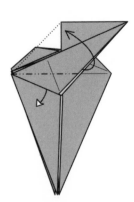

20. Pull out some loose paper.

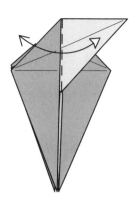

21. Fold and unfold.

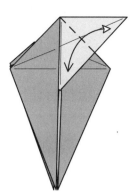

22. Fold and unfold.

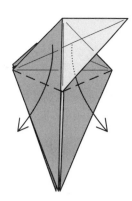

23. Open the flap downward.

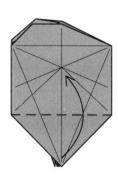

24. Fold the flap up on an existing crease.

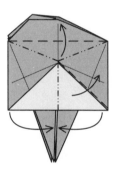

25. Bring the side corners together.

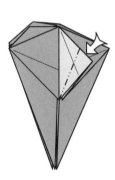

26. Reverse-fold the edge.

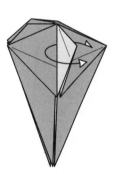

27. Unwrap a single layer of paper.

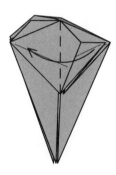

28. Fold a single layer over to the left.

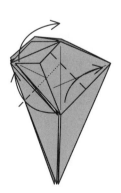

29. Fold the two bottom points out to the sides and bring the left corner up to the top.

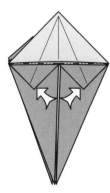

30. Reverse-fold the corners upward.

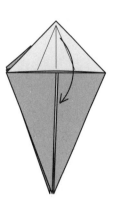

31. Fold the corner downward.

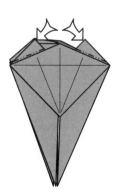

32. Reverse-fold the edges.

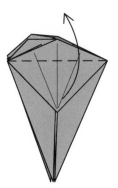

33. Fold the corner back up.

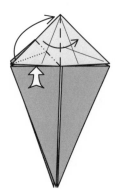

34. Squash-fold the left point upward and swing the excess paper to the right. (You will undo some folds indicated by the x-ray line.)

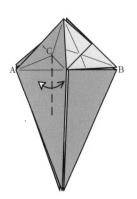

35. Bring point A over to lie on line AB; the crease runs through point C. Crease lightly and unfold.

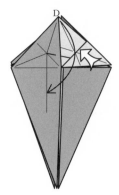

36. Bring point D down to lie on the crease you just made; crease only where shown. The model will not lie flat.

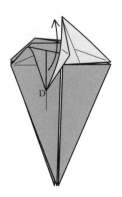

37. Unfold.

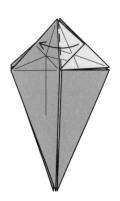

38. Fold the flap to the left.

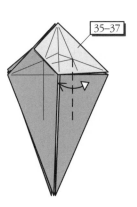

39. Repeat steps 35–37 on the right.

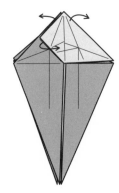

40. Lift the white flap up so that it stands out away from the model and spread the two top points slightly.

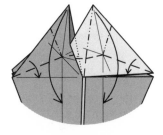

41. Fold both points down on the creases you made in steps 36 and 39 so that their tips lie on the vertical creases. In the process, you will turn the middle flap inside-out. The model will not lie flat.

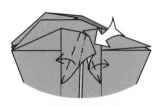

42. Squash-fold the middle layers symmetrically and flatten the model completely. Note that the valley folds lie on existing creases.

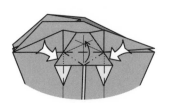

43. Petal-fold.

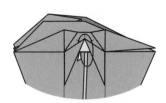

44. Turn the petal fold inside-out and tuck it up inside.

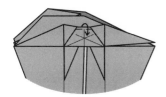

45. Fold down the upper edge.

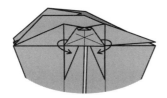

46. Bring two layers in front on each side (you must perform a closed sink on each side to do this).

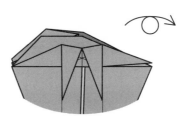

47. Turn the model over.

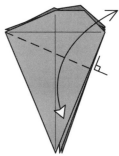

48. Fold and unfold.

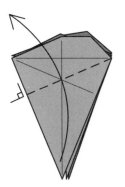

49. Fold the point up to the left.

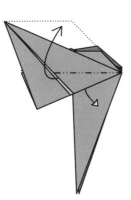

50. Pull out some loose paper.

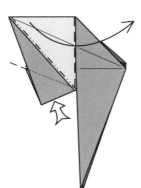

51. Squash-fold the point over to the right.

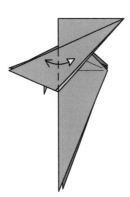

52. Fold and unfold.

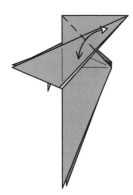

53. Fold and unfold.

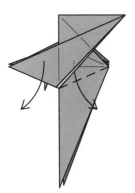

54. Unfold the upper flap.

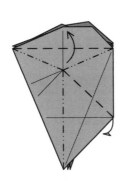

55. Crimp the flap and swing the excess paper over to the right.

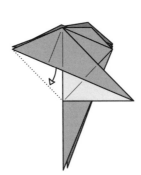

56. Pull out some loose paper.

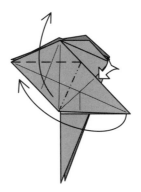

57. Squash-fold the point over to the left.

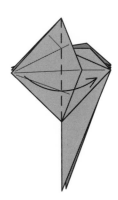

58. Fold one layer to the right.

Grasshopper 63

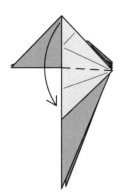

59. Fold one layer down.

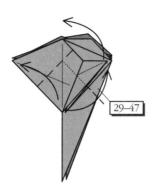

60. Repeat steps 29–47 on this side in mirror image.

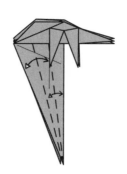

61. Fold and unfold, dividing the long point into thirds. Fold through both layers of the point. Repeat on the rear point.

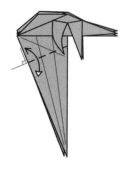

62. Fold and unfold through the intersection of the two creases. Repeat on the rear point.

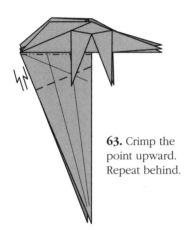

63. Crimp the point upward. Repeat behind.

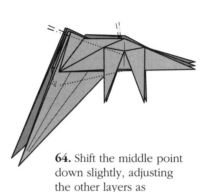

64. Shift the middle point down slightly, adjusting the other layers as necessary. Flatten firmly.

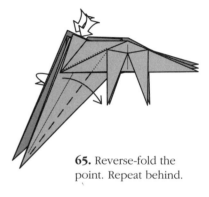

65. Reverse-fold the point. Repeat behind.

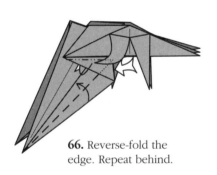

66. Reverse-fold the edge. Repeat behind.

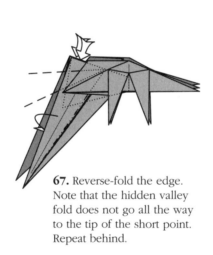

67. Reverse-fold the edge. Note that the hidden valley fold does not go all the way to the tip of the short point. Repeat behind.

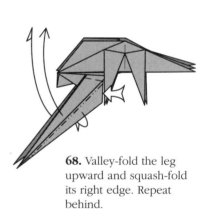

68. Valley-fold the leg upward and squash-fold its right edge. Repeat behind.

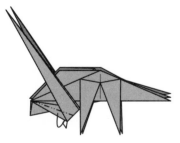

69. Mountain-fold the underside of the leg. Repeat behind.

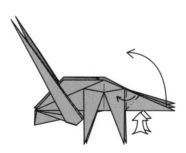

70. Squash-fold the front and back points.

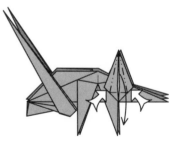

71. Petal-fold the point downward. Repeat behind.

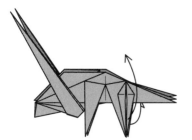

72. Fold the points upward.

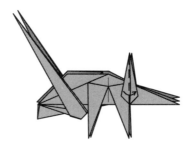

73. Close up the points.

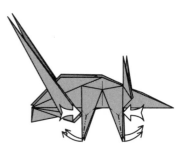

74. Double-rabbit-ear-fold four points. The result is neater if you make the folds directly, rather than squash- and petal-folding as you did in steps 71–73.

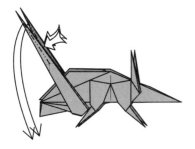

75. Double-rabbit-ear-fold the legs.

76. Squash-fold the point symmetrically. You needn't make the creases sharp. Steps 76–78 can be performed together, which gives a cleaner result.

77. Pull the loose paper out to the sides and swing the point down.

78. Mountain-fold the head in half.

79. Squash-fold the corner. Repeat behind.

80. Reverse-fold the tip up inside.

81. Reverse-fold the two points to the right.

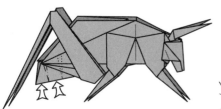

82. Crimp the abdomen.

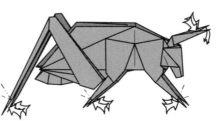

83. Crimp all six feet. Reverse-fold both antennae downward.

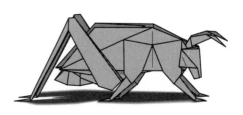

84. Grasshopper.

◆ Black Pine Sawyer ◆

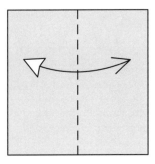

1. Fold and unfold.

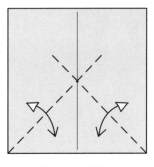

2. Fold and unfold. Crease lightly.

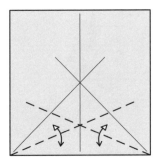

3. Fold and unfold. Again, crease lightly.

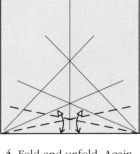

4. Fold and unfold. Again, crease lightly.

Sawyers are boring beetles — which is a statement about their habits, not their appeal. That is, their larvae burrow around inside trees (primarily downed and fire-damaged ones) eating the inner bark. The Black Pine Sawyer is distinguished among other sawyers by its long antennae. If you press your ear up against the trunk of an infested tree, you can hear the larvae chewing their way through the bark.

5. Fold and unfold through the intersections of the two creases on each side. Make these creases sharp.

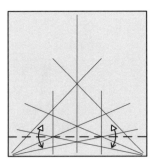

6. Fold and unfold through the same intersections.

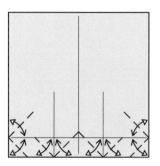

7. From now on, we will ignore the creases you made in steps 2–4. Crease the angle bisectors where indicated.

8. Fold the corners over and over.

9. Fold and unfold along angle bisectors.

10. Fold the corners up.

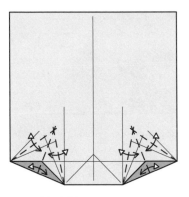

11. Add more creases.

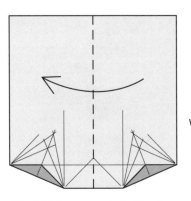

12. Fold the paper in half and rotate 1/4 turn counterclockwise.

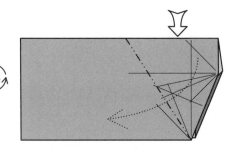

13. Reverse-fold the right side into the model.

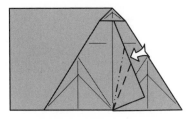

14. Fold one flap to the left and spread-sink the small hood at the top.

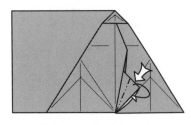

15. Reverse-fold the layer out from the inside.

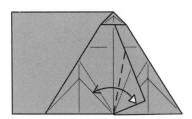

16. Fold the flap over to the diagonal crease and unfold.

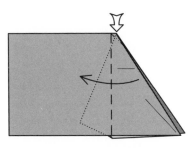

17. Reverse-fold in and out on the existing creases.

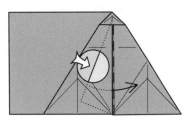

18. Reverse-fold the edge.

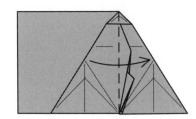

19. Fold the flap back to the right.

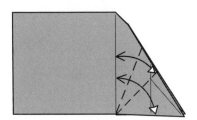

20. Fold and unfold along an angle bisector; then bisect one of the new angles as well.

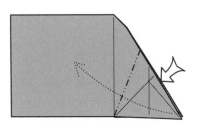

21. Reverse-fold the crease to the inside on the crease you just made.

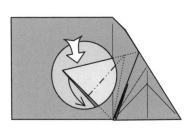

22. Reverse-fold the point down to the bottom of the model.

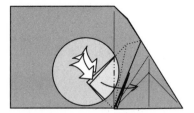

23. Reverse-fold two corners to the right on existing creases.

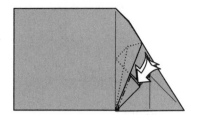

24. Reverse-fold two corners.

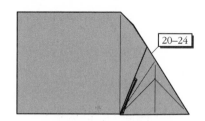

20–24

25. Repeat steps 20–24 on the far side.

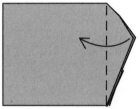

26. Fold one flap back to the left.

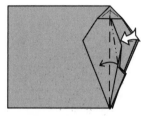

27. Spread-sink the narrow flap.

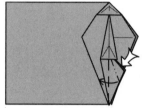

28. Spread-sink the next flap down.

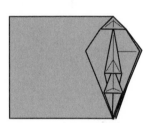

29. Turn the model over.

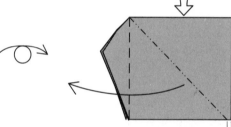

30. Squash-fold. Note that the mountain fold does not go all the way to the corner. Turn the model over again.

31. We will focus attention on the white strip at the bottom for steps 32–34.

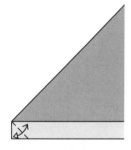

32. Fold and unfold; repeat on the right side (not shown).

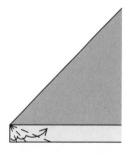

33. Fold over and over; repeat on the right.

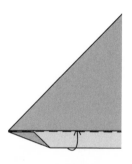

34. Tuck the long white strip across the bottom up inside the model.

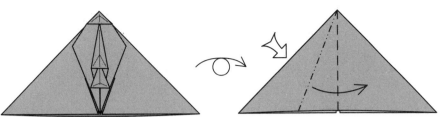
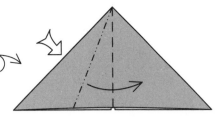
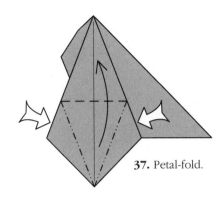

35. Turn the model over.

36. Squash-fold.

37. Petal-fold.

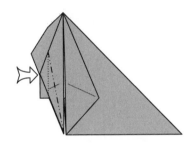
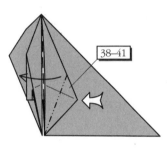
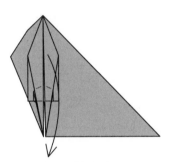

38. Spread-sink the point.

39. Fold the top of the flap to the left and pull out the pocket.

40. Fold and unfold through two layers.

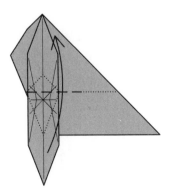
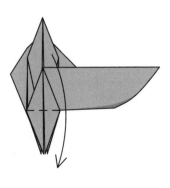
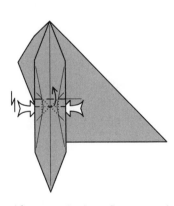

41. Sink two edges together.

42. Repeat steps 38–41 on the right flap.

43. Fold the long point down.

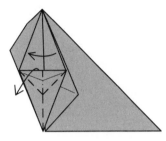

44. Fold the long point and two short points behind it upward. Crease only through the thick layers.

45. Fold all layers back down.

46. Crimp the long flap upward on the existing creases. To do this, you must sink two hidden edges (see next step).

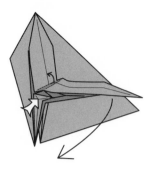

47. This view shows the two hidden edges that are sunk.

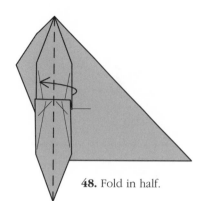

48. Fold in half.

36–48

49. Repeat steps 36–48 on the right.

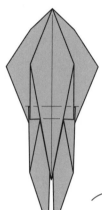

50. Crease through all layers along the top of the hidden pleat.

51. Turn the model over.

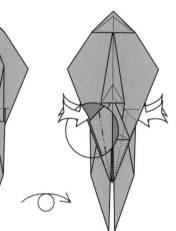

52. Sink the four hidden corners.

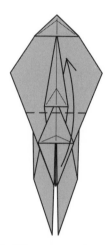

53. Lift up two points on the crease you made in step 51; two more points will stand straight out from the model.

54. Sink the middle edge of the point that stands straight out.

55. Pinch the flap together where it meets the rest of the model.

56. Fold the point upward and flatten it.

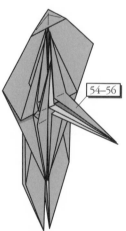

54–56

57. Repeat steps 54–56 on the right.

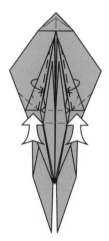

58. Swivel-fold one layer on each side and tuck it into the pockets along the legs.

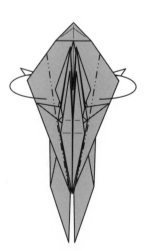

59. Mountain-fold the edges behind.

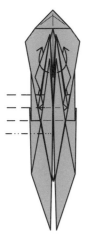

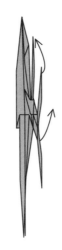

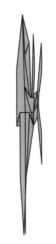

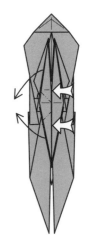

60. Pleat the two points upward; the upper point gets longer, while the lower one shortens. See the next step for a side view.

61. Side view of the pleats.

62. Complete pleats. Repeat on the other side.

63. Reverse-fold two points to the left.

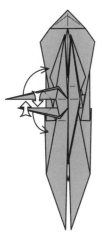

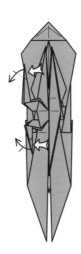

64. Reverse-fold each leg again.

65. Reverse-fold each leg again.

66. Reverse-fold the remaining leg.

67. Mountain-fold the top edge of the leg; mountain-fold the base of the leg and hook it around a flap of paper.

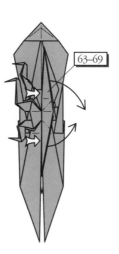

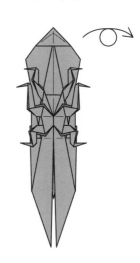

68. Reverse-fold the leg.

69. Reverse-fold the foot.

70. Repeat steps 63–69 on the right.

71. Turn the model over.

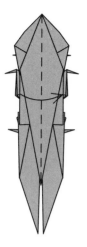
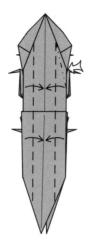
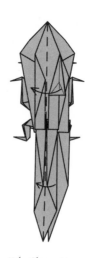
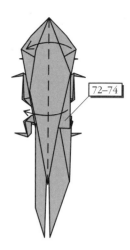

72. Fold one layer from left to right.

73. Fold the sides in to the center line; spread-sink the upper right corner.

74. Close it up again.

75. Repeat steps 72–74 on the right.

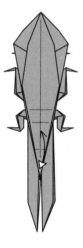
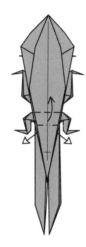
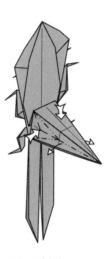
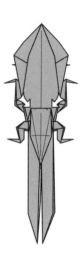

76. Fold and unfold.

77. Pleat one layer upward and open out one of the pleats on each side of the point. It becomes a four-sided pyramid that stands out away from the body.

78. Add the creases shown and collapse the point.

79. Sink the corners.

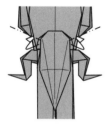
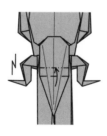
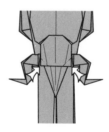
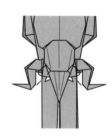

80. Mountain-fold the corners underneath.

81. Pleat.

82. Reverse-fold two corners.

83. Mountain-fold the two corners at the base of the reverse folds and tuck them into the pockets behind.

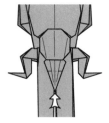

84. Sink the tip.

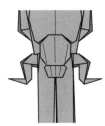

85. Turn the model over.

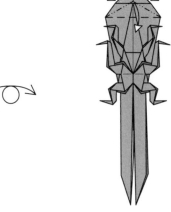

86. Squash the top point from side to side and swing the tip over to one side.

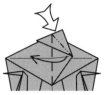

87. Squash-fold the top and swing the point over to the left.

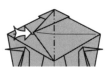

88. Closed-sink the point to the right.

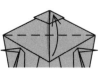

89. Fold the point upward.

90. Closed-sink the point.

91. Pleat the sides as tightly as possible.

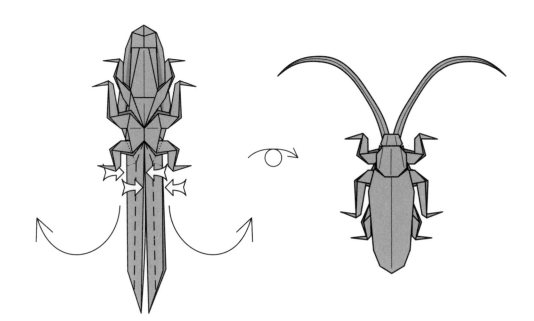

92. Pinch the antennae and curl them out to the sides. Turn the model over.

93. Black Pine Sawyer.

◆ **Dragonfly** ◆

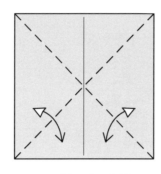

1. Fold and unfold.

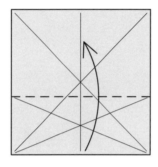

2. Fold and unfold.

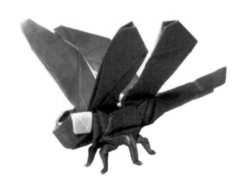

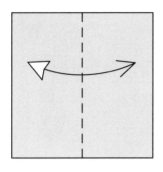

3. Fold and unfold.

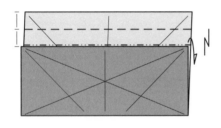

4. Fold the bottom flap upward.

Dragonflies are one of the oldest orders of insects, with fossils that have been dated to 300 million years old. They are all hunters, and are characterized by long, slender bodies and wings and large compound eyes. Their legs are not useful for walking, but are used only for perching and for holding their prey.

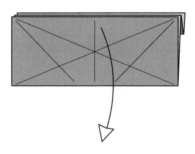

5. Pleat the top.

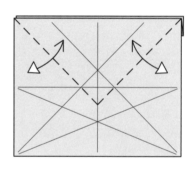

6. Unfold one layer. Leave the pleat in place.

7. Fold and unfold.

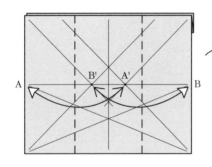

8. Fold A to A' and unfold. Fold B to B' and unfold. Turn the paper over.

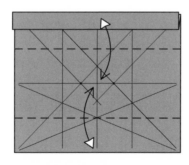

9. Fold and unfold. Turn the paper back over.

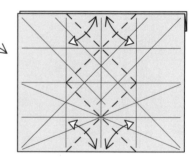

10. Fold and unfold.

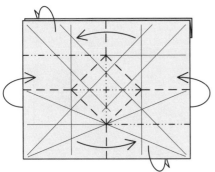

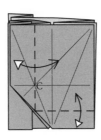

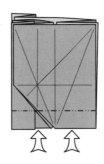

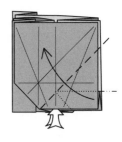

11. Collapse along existing creases.

12. Fold and unfold. The vertical crease goes through point C; the horizontal crease meets the vertical one at the diagonal edge. Repeat behind.

13. Open-sink. Repeat behind.

14. Squash-fold the flap and fold it up to the left. Repeat behind.

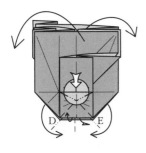

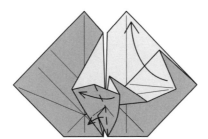

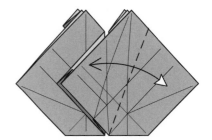

15. Sink the hidden white edge inside and bring points D and E together, forming a tiny Preliminary Fold at the bottom.

16. Flatten the model.

17. Fold and unfold along an angle bisector.

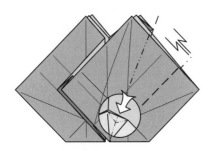

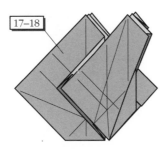

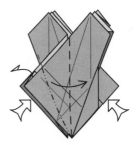

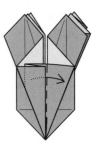

18. Crimp symmetrically. Note the sink you must make inside the model to keep it symmetric.

19. Repeat steps 17–18 on the other side.

20. Squash-fold. The extra layers inside the squash fold go to the left. Repeat behind, symmetrically.

21. Pull the inside of the pocket out. Repeat behind.

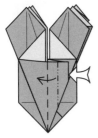

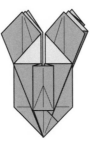

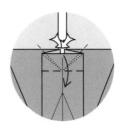

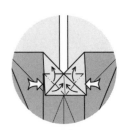

22. Spread-sink the flap you just pulled out. Do not repeat behind.

23. Like this. Now we will work on the top of the spread-sunk region.

24. Squash-fold the two white corners.

25. Squash-fold the sides inward.

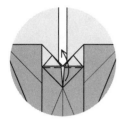 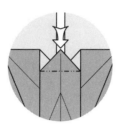 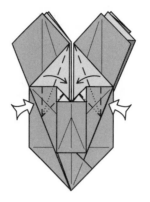 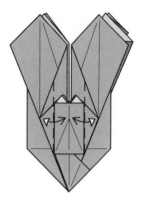

26. Fold the point upward.

27. Sink the point.

28. Reverse-fold the side edges.

29. Fold and unfold.

30. Sink the side points.

31. Turn the model over.

32. Reverse-fold the sides in.

33. Fold and unfold.

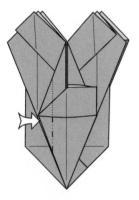 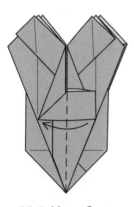 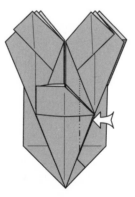 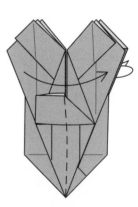

34. Sink the point; its upper half is covered by the pleated layers.

35. Fold one flap to the left.

36. Repeat step 34 on the right.

37. Fold one large flap to the right in front and one to the left behind.

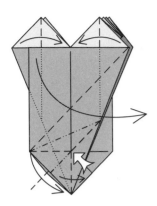

38. Squash-fold the pocket at the lower right as you fold in the sides at the top. Gather the excess paper into a single flap and swing it over to the right.

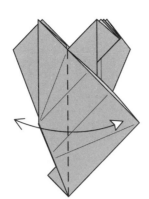

39. Fold and unfold.

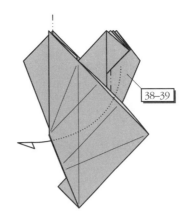

40. Repeat steps 38–39 behind.

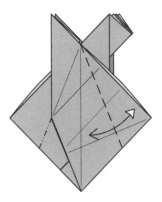

41. Fold and unfold. Repeat behind.

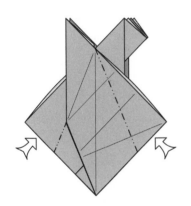

42. Reverse-fold the edge. Repeat behind.

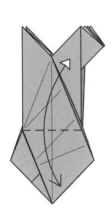

43. Fold and unfold.

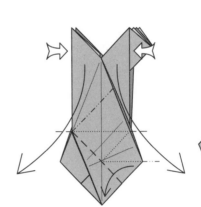

44. Squash-fold the two top points downward.

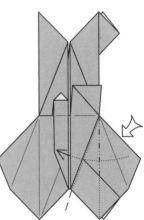

45. Reverse-fold the edge to the left.

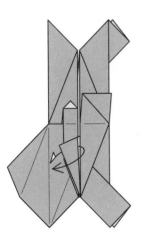

46. Unwrap a single layer of paper.

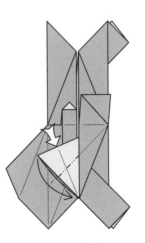

47. Reverse-fold the point downward.

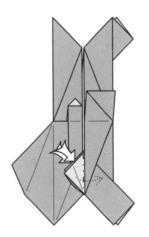

48. Reverse-fold two edges.

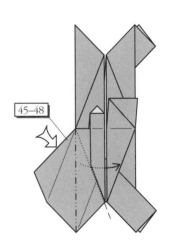

49. Repeat steps 45–48 on the left.

Dragonfly 77

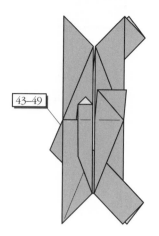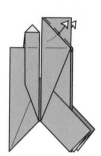

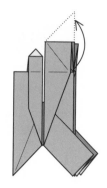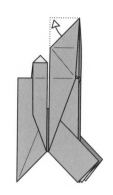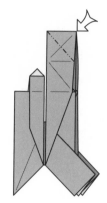

50. Repeat steps 43–49 behind.

51. Reverse-fold one layer upward. Repeat behind.

52. Reverse-fold the point upward.

53. Pull out a single layer of paper.

54. Sink the corner.

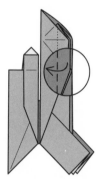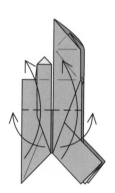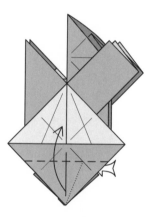

55. Valley-fold the middle layer to one side.

56. Fold two points upward; two smaller points underneath move out to the sides. Repeat behind.

57. Fold one point upward, squash-folding the layer underneath (like half of a Bird Base).

58. Pull a single layer of paper out from the inside.

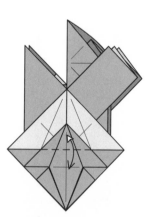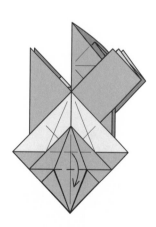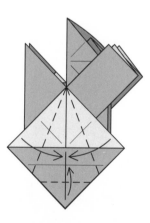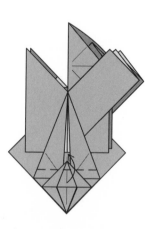

59. Fold and unfold.

60. Fold the flap down.

61. Fold the sides in and the bottom up on existing creases.

62. Fold the remainder of the flap upward on the existing crease.

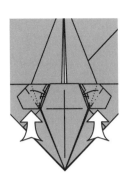

63. Squash-fold the corners and tuck the edges into the pockets shown.

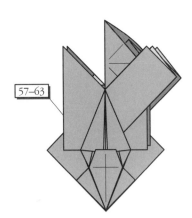

64. Repeat steps 57–63 on the other side.

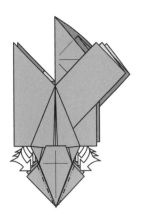

65. Reverse-fold three edges on each side.

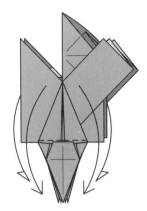

66. Fold down two flaps; repeat behind.

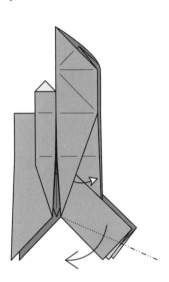

67. Pull out some loose paper; repeat behind.

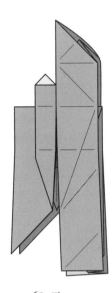

68. Flatten.

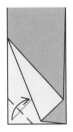

69. This is a view of the rear flap. Fold the corner up to the edge.

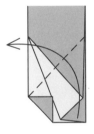

70. Fold the flap up to the left.

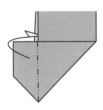

71. Tuck the edge into the pocket. Repeat steps 69–71 on the near flap.

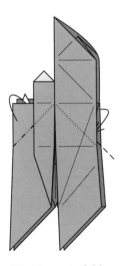

72. Mountain-fold four corners to the interior (the ones on the right are hidden).

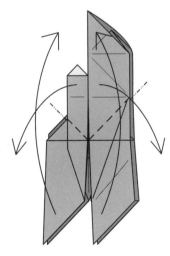

73. Carefully crimp the head (left) and abdomen (right) downward; at the same time, allow the four wings to swing upward. Flatten.

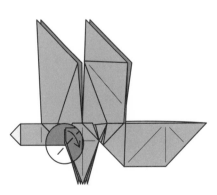

74. Tucked inside the model is a pleat containing three layers, which was formed by the crimp in the last step. Fold this pleat downward; repeat on the right, and on each side behind. This evens out the layers of the crimp somewhat, and helps it hold its shape.

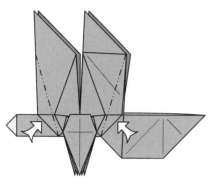

75. Closed-sink the corners shown. Repeat behind.

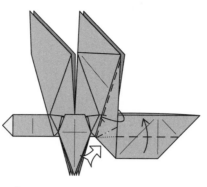

76. Swivel-fold the edge and tuck the flap into the pocket behind the closed sink. Repeat behind.

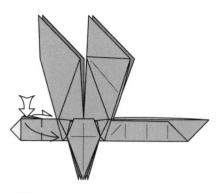

77. Squash-fold the middle edge and swing the white corners toward the right in front and behind.

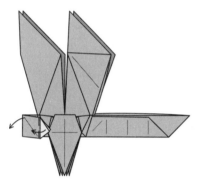

78. Swing the head downward toward the left. Open out the white eye; repeat behind.

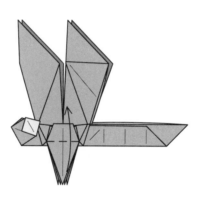

79. Fold one flap up in front and behind.

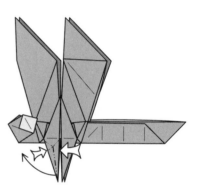

80. Double-rabbit-ear the thick point to the left to make a leg.

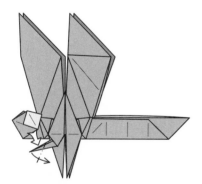

81. Reverse-fold the point downward.

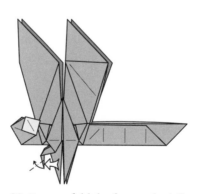

82. Reverse-fold the foot to the left.

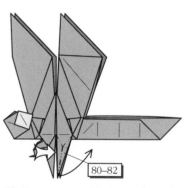

83. Repeat steps 80–82 on the right and twice behind.

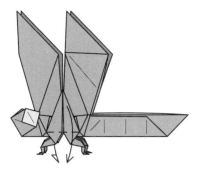

84. Fold the point down in front and behind.

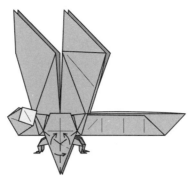

85. Fold a rabbit ear.

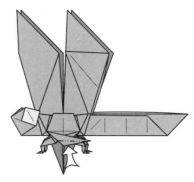

86. Sink the edge.

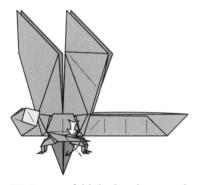

87. Reverse-fold the leg downward.

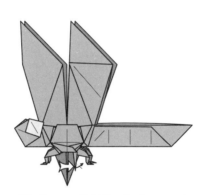

88. Reverse-fold the foot upward.

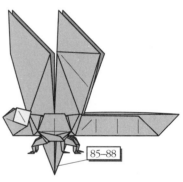

85–88

89. Repeat steps 85–88 behind.

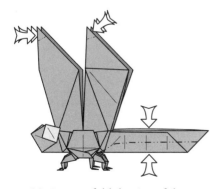

90. Reverse-fold the tips of the wings and narrow the abdomen.

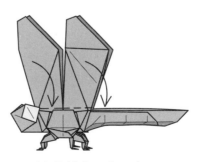

91. Fold the wings down.

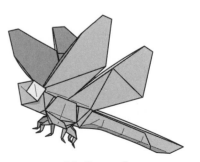

92. Dragonfly.

Dragonfly 81

◆ Hercules Beetle ◆

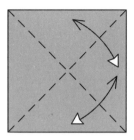

1. Fold and unfold along the diagonals.

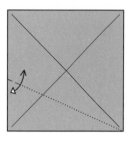

2. Crease the angle bisector, but make it sharp only where it hits the edge.

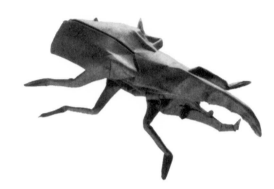

The Hercules Beetle is one of several large horned beetles found in Central and South America. As with the Samurai Helmet Beetle, the males use their horns in combat with other males, while the females have reduced or nonexistent horns.

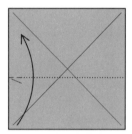

3. Fold the bottom up to the top so the left edges are aligned; the crease hits the edge at the same point as the last crease.

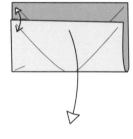

4. Fold the top edge down over the white edge; pinch at the left side, and unfold the paper completely.

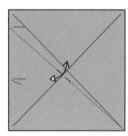

5. Connect the crease you just made to the lower right corner with a crease; make the crease sharp where it crosses the diagonal.

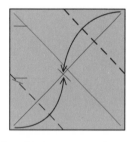

6. Fold the upper right and lower left corners to the intersection of the crease you just made with the diagonal of the square.

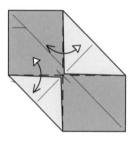

7. Fold and unfold.

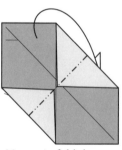

8. Mountain-fold the paper in half along the diagonal.

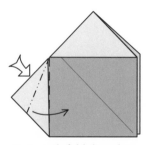

9. Squash-fold the edge.

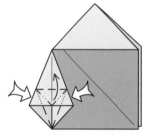

10. Petal-fold the edge.

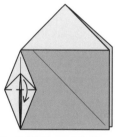

11. Fold the point down.

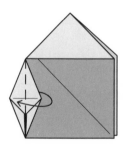

12. Fold the white part in half.

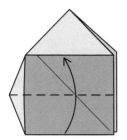

13. Fold one layer up so that the raw edges touch one another.

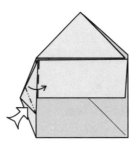

14. Spread-sink the corner symmetrically.

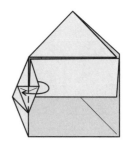

15. Fold the layer in half.

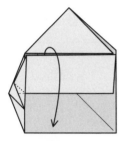

16. Fold the raw edge back down, stretching a pleat at the left.

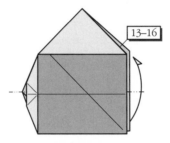

17. Repeat steps 13–16 behind.

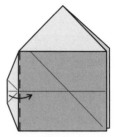

18. Fold one layer to the right and rotate the model 1/4 turn clockwise.

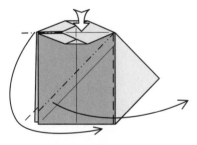

19. Open out the large pocket on the left and squash-fold the model symmetrically.

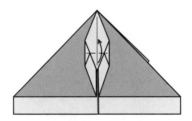

20. Fold the small point up.

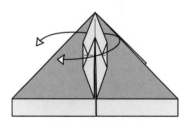

21. Unwrap a single layer of paper.

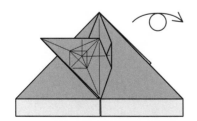

22. Turn the model over.

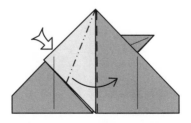

23. Squash-fold the white flap.

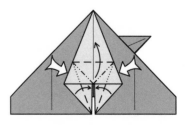

24. Petal-fold the edge.

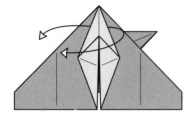

25. Unwrap a single layer of paper.

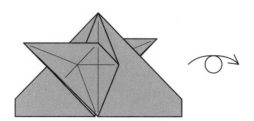

26. Turn the model over.

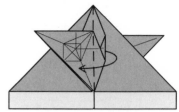

27. Fold one layer to the left.

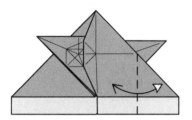

28. Fold and unfold.

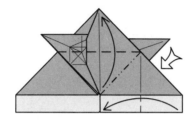

29. Swivel-fold.

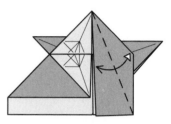

30. Fold and unfold.

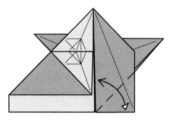

31. Fold and unfold.

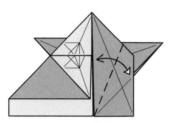

32. Fold and unfold.

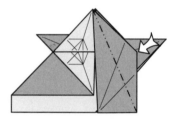

33. Sink the corner.

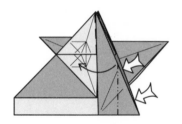

34. Squash-fold the edge.

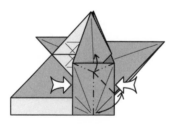

35. Squeeze the sides together and swing the excess paper over to the right.

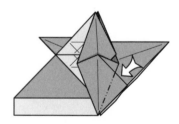

36. Reverse-fold the edge.

37. Fold one layer back to the right.

38. Fold one point down.

39. Fold one flap to the right.

40. Swing one flap to the right.

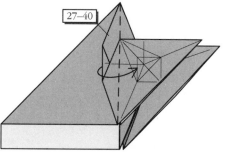

41. Repeat steps 27–40 on the left.

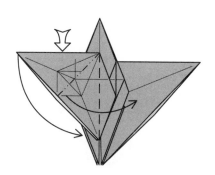

42. Squash-fold the point.

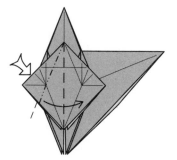

43. Squash-fold the edge.

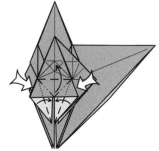

44. Petal-fold the edge.

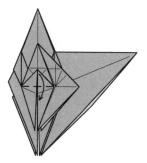

45. Fold the point down.

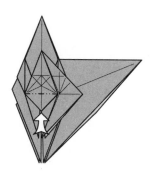

46. Sink the point up inside.

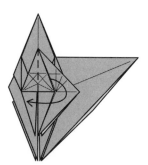

47. Fold one layer to the left.

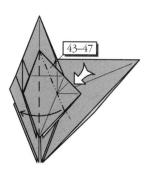

48. Repeat steps 43–47 on the right.

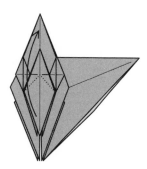

49. Fold the point up, stretching out the pleats.

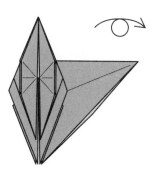

50. Turn the model over.

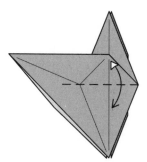

51. Fold and unfold.

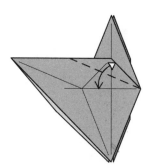

52. Fold and unfold.

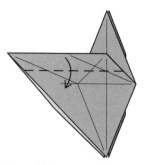

53. Fold the top edge down.

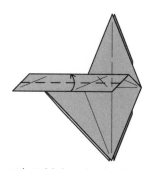

54. Fold the edge back up.

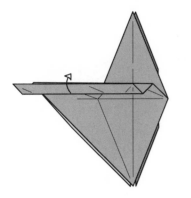

55. Unfold to step 53.

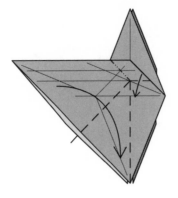

56. Fold an asymmetric rabbit ear.

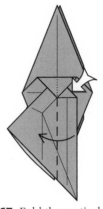

57. Fold the vertical edge over to the left.

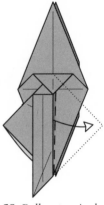

58. Pull out a single layer of paper.

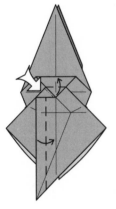

59. Swivel-fold, using the existing creases.

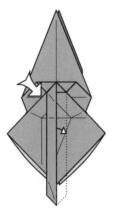

60. Pull out some loose paper.

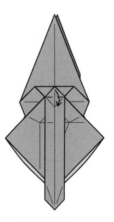

61. Fold down the small point.

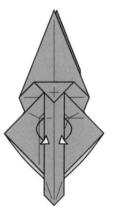

62. Bring two layers to the front on each side.

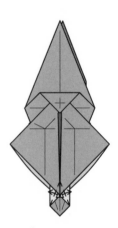

63. Fold and unfold.

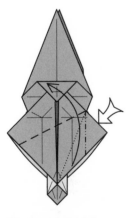

64. Squash-fold the right edge so that the raw edge lies along the top of the small right triangle.

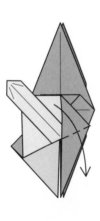

65. Fold the flap back down.

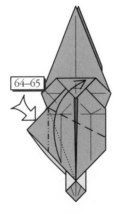

66. Repeat steps 64–65 on the left.

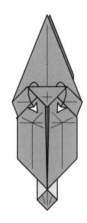

67. Bring two layers of paper in front.

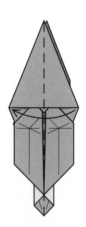

68. Fold one layer to the left.

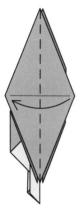

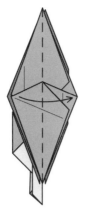

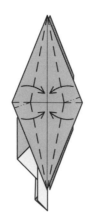

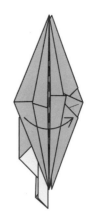

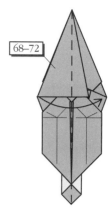

69. Fold the right flap over to the left, releasing the trapped layers behind it.

70. Fold one layer back to the right.

71. Fold a rabbit ear on each side with a single flap.

72. Fold one layer back to the right.

73. Repeat steps 68–72 on the left.

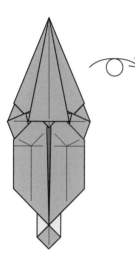

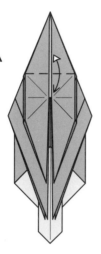

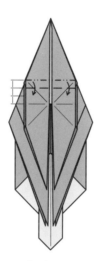

74. Turn the model over.

75. Fold and unfold through a single layer.

76. Pleat the point.

77. Step 78 will focus on the pleated region.

78. Reverse-fold the corners.

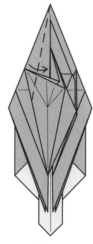

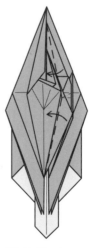

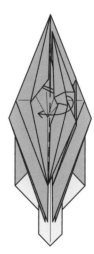

79. Fold one layer to the right.

80. Fold two layers of point A to the right, and spread-sink the corner.

81. Fold one edge to the center line.

82. Fold a long, skinny rabbit ear over one layer.

83. Fold one layer to the left.

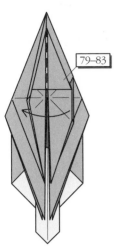 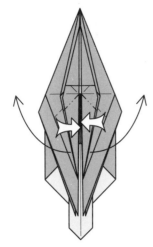 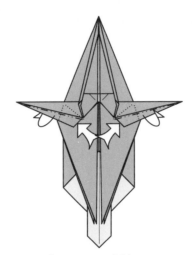 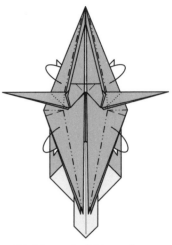

84. Repeat steps 79–83 on the right.

85. Reverse-fold two points to the side, separating the layers between a wide and a narrow layer on each point.

86. Mountain-fold two layers underneath, reverse-folding where the legs meet the body.

87. Mountain-fold one layer behind all the way around, forming a slight rabbit ear to accommodate the excess paper in the middle.

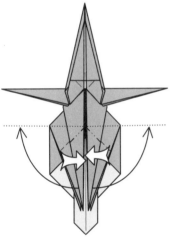

88. Reverse-fold two more points.

89. Reverse-fold one layer underneath on each leg.

90. Mountain-fold one layer underneath on each side.

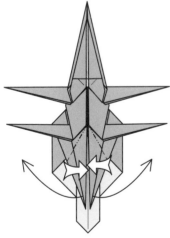 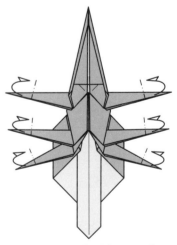

91. Reverse-fold the remaining pair of points.

92. Reverse-fold one layer underneath on each leg.

93. Mountain-fold the tip of each point; make the crease sharp, but don't fold the point all the way behind. The model will not lie flat.

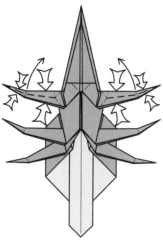

94. Pinch each of the front legs above and below the mountain fold, and swing them upward slightly.

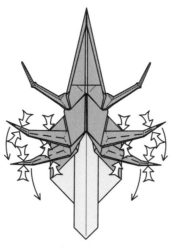

95. Pinch each of the four remaining legs and swing them downward.

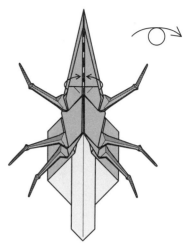

96. Bring the edges of the near flap together; turn the model over.

97. Push in the sides of the abdomen. Round the edges of the near point.

98. Reverse-fold the tip of the abdomen. Lift up the upper point on the head.

99. Tuck the white point on the abdomen inside the body. Reverse-fold the small point on the lower jaw upward.

100. Crimp the lower jaw. Curve the upper jaw. Shape and round the body.

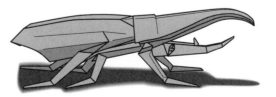

101. Hercules Beetle.

◆ Long-Necked Seed Bug ◆

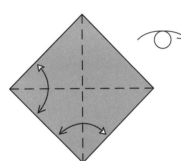

1. Fold and unfold. Turn the paper over.

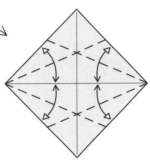

2. Fold and unfold along the angle bisectors.

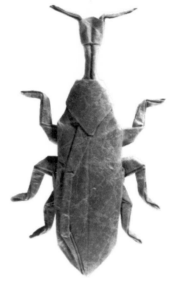

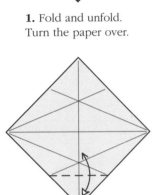

3. Fold and unfold.

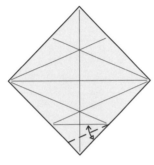

4. Fold and unfold along an angle bisector.

Although many people refer to all insects as "bugs," entomologists reserve the term for members of the order Hemiptera. True bugs are distinguished from beetles (Coleoptera) in part by their wings. In bugs, the first pair of wings are membranous and lie flat over the back, usually overlapping, while in beetles, the forewings are hardened and lie side-by-side over the abdomen. The Long-Necked Seed Bug is further distinguished from other bugs by its elongated "neck," which is actually an extension of the head.

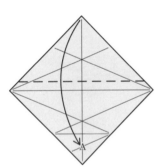

5. Fold the top corner down to point A, the intersection of two creases.

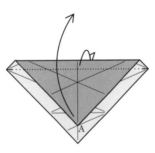

6. Mountain-fold the top edge of the model behind and swing the flap upward.

7. Fold the bottom corner up to the top and unfold.

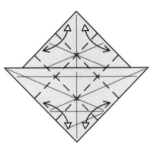

8. Fold and unfold through the crease intersections.

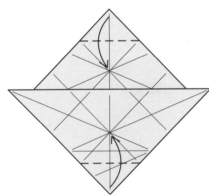

9. Fold the top corner down and the bottom corner up.

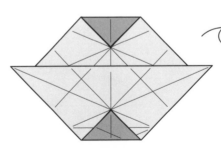

10. Turn the model over.

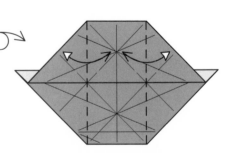

11. Fold and unfold.

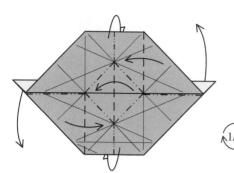
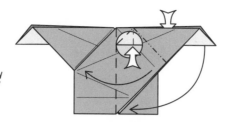
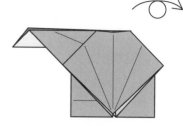

12. Collapse the paper using the existing creases. Rotate the model 1/4 turn clockwise.

13. Push the pleat upward from the inside and squash-fold the flap symmetrically.

14. Turn the model over.

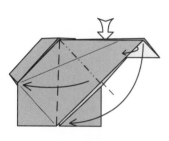
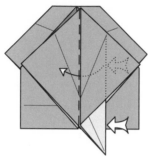
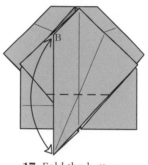
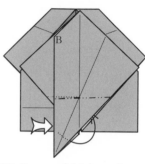

15. Squash-fold the flap at the upper right, folding the middle layer to one side.

16. Reverse-fold the vertical edge out to the left.

17. Fold the bottom corner up to point B and unfold.

18. Reverse-fold the point up inside the model to point B. You will have to partially unfold the flap to do this without trapping paper.

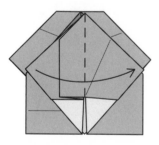
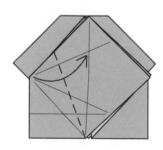
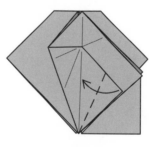
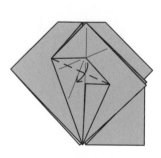

19. Fold one narrow and one wide flap to the right.

20. Fold the corner up to lie on the center line.

21. Fold the corner in to lie on the center line.

22. Fold the remaining corner down.

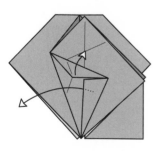
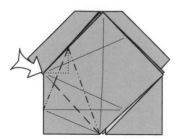
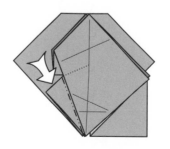
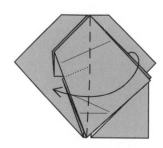

23. Unfold to step 20.

24. Sink in and out on an existing crease.

25. Reverse-fold the edge.

26. Fold both layers to the left.

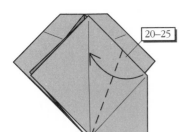

27. Repeat steps 20–25 on the right.

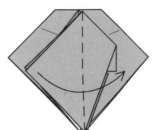

28. Fold one layer back to the right.

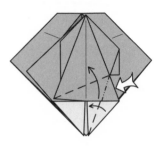

29. Squash-fold the edge symmetrically.

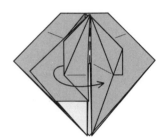

30. Swivel-fold an edge.

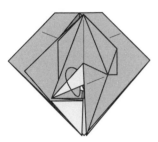

31. Tuck the raw edge underneath.

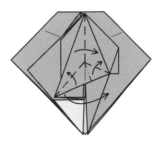

32. Form a rabbit ear from a double layer of paper and fold one point to the right.

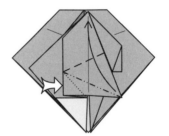

33. Swivel-fold the point upward.

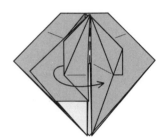

34. Fold one flap to the right.

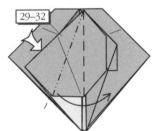

35. Repeat steps 29–32 on the left.

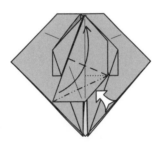

36. Fold the point up to the top of the model.

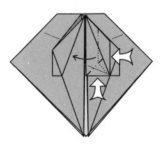

37. Spread-sink the flap symmetrically.

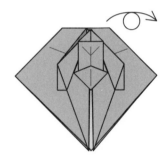

38. Turn the model over.

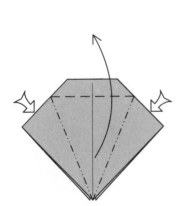

39. Petal-fold the flap.

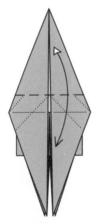

40. Fold the top of the flap down so that the crease lines up with the hidden edge. Unfold.

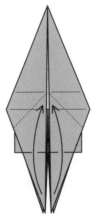

41. Fold one point up on each side.

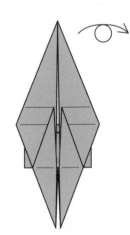

42. Turn the model over.

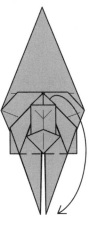

43. Fold one thick layer down.

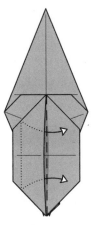

44. Pull two layers of paper out from the pocket.

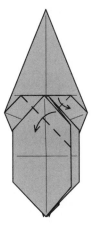

45. Open out the pocket and flatten it completely.

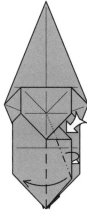

46. Swing one layer to the left.

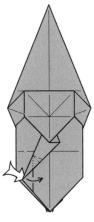

47. Fold some of the flap over to the right, crimping where necessary.

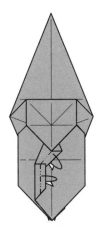

48. Mountain-fold the edge underneath.

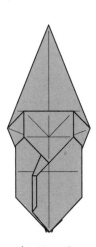

49. Turn the model over.

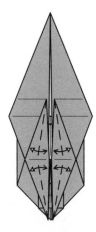

50. Fold and unfold through the near layers.

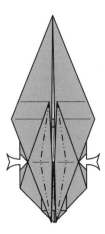

51. Sink the edges.

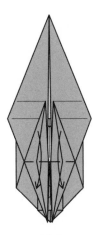

52. Fold the two points down.

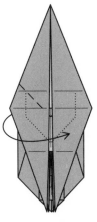

53. Lift up a single flap. The model will not lie flat.

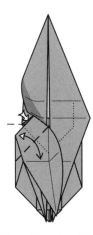

54. Fold and unfold.

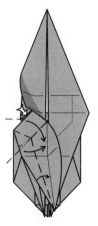 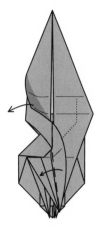 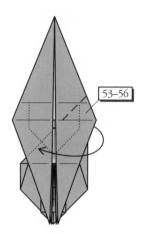 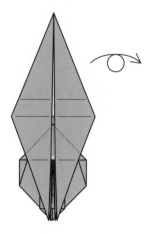

55. Fold the flap down and simultaneously fold one layer to the middle of the model.

56. Close the flap and flatten the model.

57. Repeat steps 53–56 on the right.

58. Turn the model over.

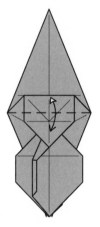 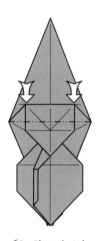 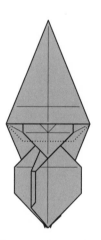 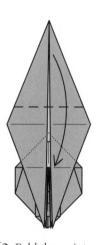

59. Fold and unfold.

60. Closed-sink the edge.

61. Turn the model back over.

62. Fold the point down on the existing crease.

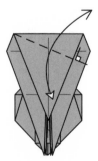 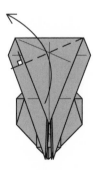 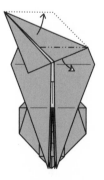 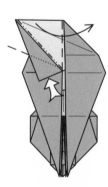

63. Fold and unfold.

64. Fold the point up to the left.

65. Pull out some loose paper.

66. Squash-fold the flap over to the right.

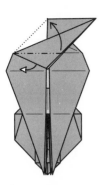

67. Pull out some loose paper.

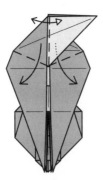

68. Fold the white point from side to side. Then open it out flat.

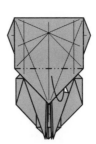

69. Mountain-fold the corner underneath.

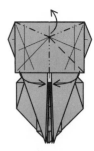

70. Bring the corners together and crimp the middle of the paper upward.

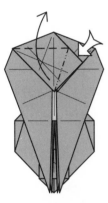

71. Squash-fold the edge.

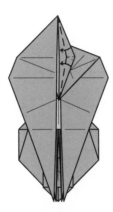

72. Fold a narrow rabbit ear from the vertical triangle.

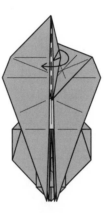

73. Fold the narrow flap over to the left.

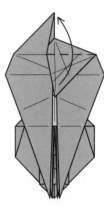

74. Fold the right point upward as far as possible.

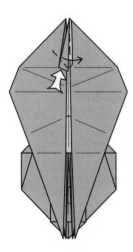

75. Squash-fold the point.

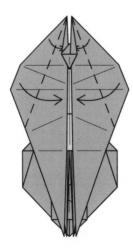

76. Valley-fold the edges in to the center line and tuck them under the squash fold from the last step.

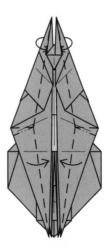

77. Fold the edges in to the center line, forming a long, skinny rabbit ear on each side.

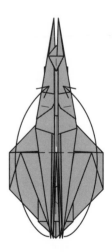

78. Fold all four points as far up as possible.

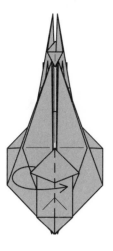

79. Fold one layer to the right.

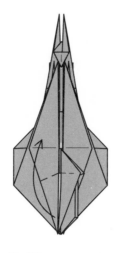

80. Lift up one point.

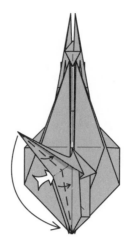

81. Fold one edge in to the center line.

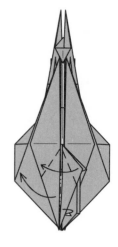

82. Fold one layer to the left and reverse-fold the bottom point outward.

83. Fold one edge up, reverse-folding it where the point joins the body.

84. Mountain-fold the remaining edge behind.

85. Mountain-fold one layer behind.

86. Fold one point down.

87. Mountain-fold the edge and tuck it inside the leg, swiveling at the top.

88. Reverse-fold the small corner.

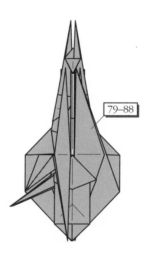

89. Repeat steps 79–88 on the right.

90. Turn the model over.

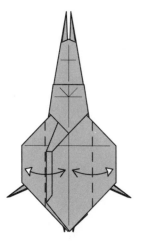

91. Fold the edges in to the center line, crease lightly, and unfold.

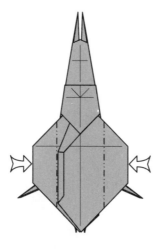

92. Carefully closed-sink the sides in on the creases you just made.

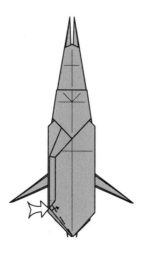

93. Fold a little bit of the edge of the wing upward.

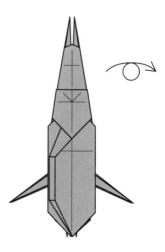

94. Turn the model over.

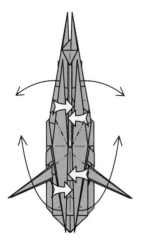

95. Reverse-fold four points out to the sides.

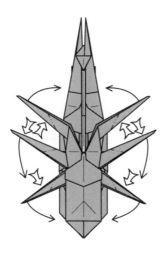

96. Reverse-fold six points.

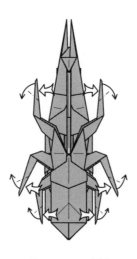

97. Reverse-fold six feet.

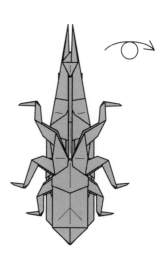

98. Turn the model over.

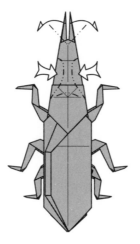

99. Pinch the sides of the neck to narrow it and curve the antennae out to the sides.

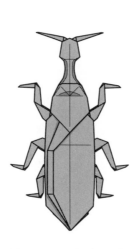

100. Long-Necked Seed Bug.

◆ Pill Bug ◆

1. Begin with the white side up. Fold and unfold along the diagonals.

2. Fold and unfold vertically and horizontally.

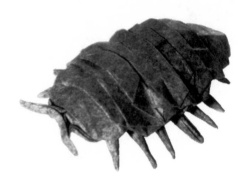

3. Fold the top edge down to the horizontal middle crease; pinch at the sides and unfold. Repeat with the bottom edge.

4. Fold the lower left corner up along a crease that connects the pinch you just made with the midpoint of the bottom edge; pinch only where shown and unfold. Repeat on the other four corners.

The Pill Bug, despite its resemblance to insects and spiders, is neither. It is a crustacean, more closely related to crabs and lobsters. Pill bugs live under rocks and logs, where they feed on rotting matter. When disturbed, they roll tightly into a nearly perfect sphere and are protected by their overlapping back plates.

5. Fold and unfold along angle bisectors. Pinch each crease sharp only where it crosses the crease you made in the previous step. Turn the paper over.

6. Fold the left side of the paper over along a vertical crease that passes through the intersections of the creases made in steps 4 and 5.

7. Turn the paper over.

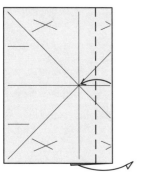 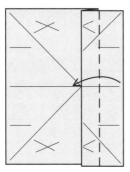 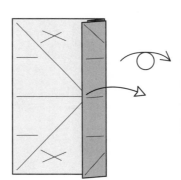 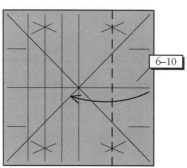

8. Bring the folded edge in to lie along the vertical crease, allowing the loose flap to swing out behind.

9. Fold the right edge over along a crease that lies on top of a folded edge.

10. Unfold completely and turn the paper over.

11. Repeat steps 6–10 on the right.

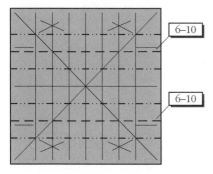 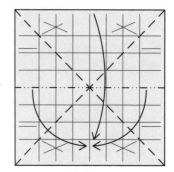

12. Repeat steps 6–10 on the top and bottom.

13. Turn the paper over.

14. Fold a Waterbomb Base.

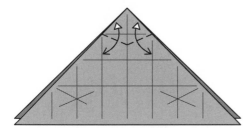 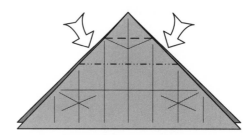

15. Fold and unfold, bringing the folded edge to a vertical crease line on each side.

16. Sink the point down and up on the existing creases.

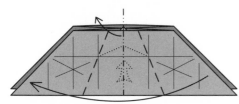 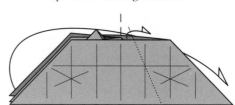

17. Simultaneously fold one flap over to the left, mountain-fold a single layer of paper in half in the middle and swing it upward, and sink the hidden horizontal edge upward on the creases you made in step 15.

18. Repeat step 17 behind.

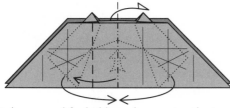 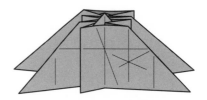

19. Sink near and far hidden edges; swing the two inner layers down and bring them together in the middle.

20. Flatten the model.

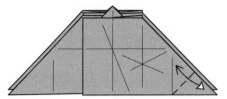 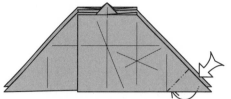 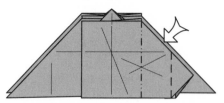

21. Fold the corner up and unfold.

22. Reverse-fold the corner inside.

23. Reverse-fold in and out.

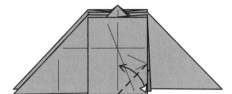 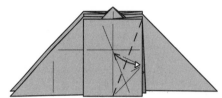 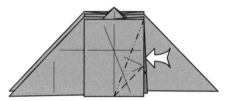

24. Fold and unfold on a single layer.

25. Fold and unfold.

26. Reverse-fold in and out.

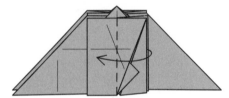 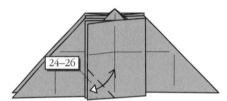 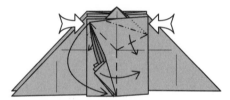

27. Fold one vertical edge over to the left.

28. Repeat steps 24–26 on this flap.

29. Bring the thick point down to the bottom, squash-folding the top corners.

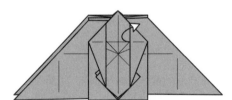 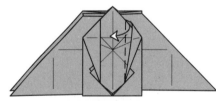 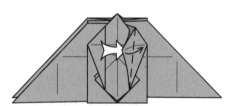

30. Open out the pocket on the right.

31. Pull the edge out of the pocket.

32. Close up the flap.

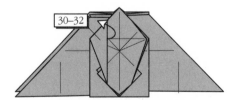 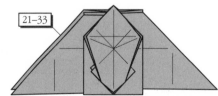 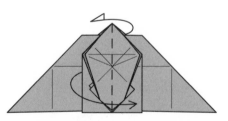

33. Repeat steps 30–32 on the right.

34. Repeat steps 21–33 behind.

35. Fold the vertical edge and its attached flaps to the right; repeat behind.

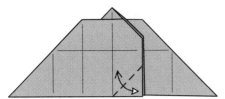

36. Fold and unfold.

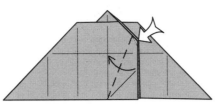

37. Fold one layer over to the left and spread-sink the upper right corner so that the crease you just made lines up with the center line of the model.

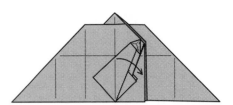

38. Unfold to step 37, leaving the spread sink in place.

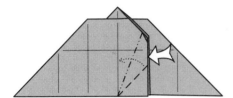

39. Reverse-fold the edge in and out.

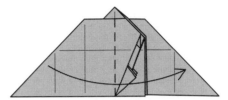

40. Swing one flap to the right.

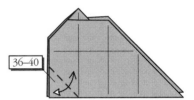

36–40

41. Repeat steps 36–40 on the left.

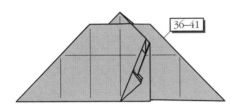

36–41

42. Repeat steps 36–41 behind.

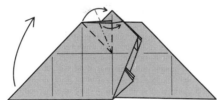

43. Open out the pocket at the top and begin to squash-fold it…

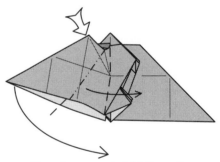

44. …then squash-fold the entire flap symmetrically.

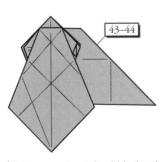

43–44

45. Repeat steps 43–44 behind.

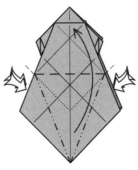

46. Petal-fold the front flap. Repeat behind.

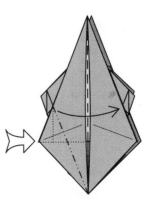

47. Spread-sink the corner.

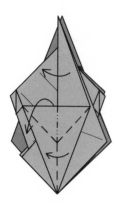

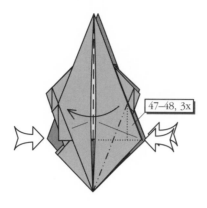

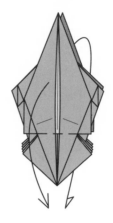

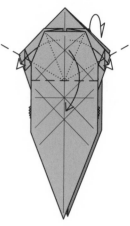

48. Pull down the horizontal edge and fold the vertical edge back to the left.

49. Repeat steps 47–48 on the right and on both flaps behind.

50. Fold one flap down in front and one down in back.

51. Fold one flap down in front and one down in back, spreading the pleated layers.

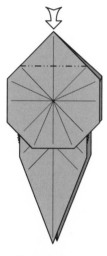

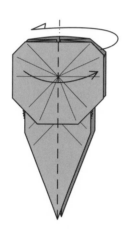

52. Sink the top point down.

53. Fold half of the layers on the left to the right and half of the layers on the right to the left.

54. Fold the right flaps back to the left, sinking the top edge downward and pulling out a single layer of paper from the middle. Repeat behind.

55. The x-ray lines show the location of the pulled-out paper.

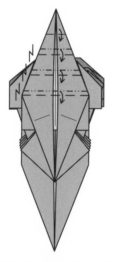

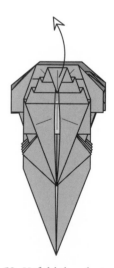

56. Pleat a single layer upward, sinking the edges and simultaneously folding one flap up. Repeat behind.

57. The x-ray lines show where the edges line up. Fold one flap up.

58. Pleat the flap and fold its tip down.

59. Unfold the pleats.

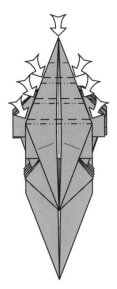

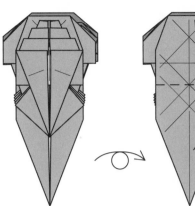

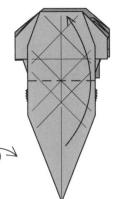

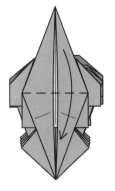

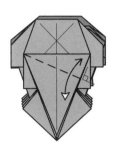

60. Sink the point up and down.

61. Turn the model over.

62. Fold the remaining flap up.

63. Fold the flap down.

64. Fold and unfold.

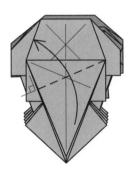

65. Fold the flap up to the left.

66. Pull out some loose paper.

67. Squash-fold the flap over to the right.

68. Pull out some loose paper.

69. Fold and unfold.

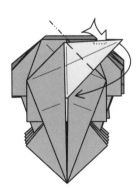

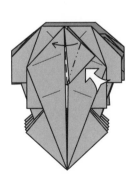

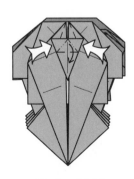

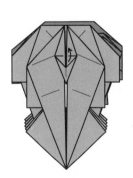

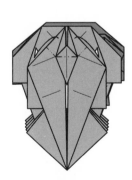

70. Outside-reverse-fold the corner.

71. Squash-fold the flap.

72. Petal-fold the edge.

73. Fold the point up.

74. Mountain-fold the corners behind. The middle point gets stretched and disappears.

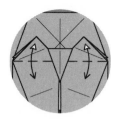 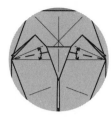 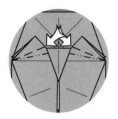

75. Enlarged view. Fold and unfold.

76. Fold and unfold.

77. Reverse-fold up and down on the creases you just made.

78. Reverse-fold the remaining edge back down.

79. Sink the top edge on each side.

 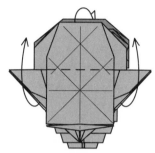

80. Reverse-fold two points—the thick point, and the one wrapped around it—on each side.

81. Fold down one flap in front and one behind.

82. Fold half of the layers at the bottom up and half of the layers at the top down.

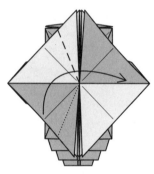 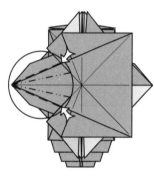 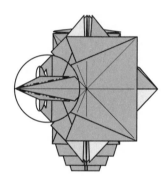

83. Your model may have the colored triangles in different positions than shown here; it doesn't matter if it does. Fold the colored triangle over to the right as far as possible.

84. Reverse-fold the edges of the hidden layers in and out.

85. Narrow the point with mountain folds.

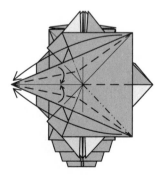 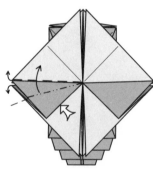

86. Bring two corners over to the left, swinging the excess paper down.

87. Repeat steps 83–86 on the right.

88. Squash-fold the colored edge, spreading the left corners up and down slightly. The white regions will buckle slightly along their edges.

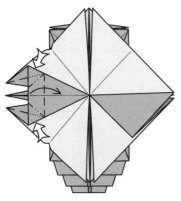

89. Petal-fold. This helps to lock the two points into position.

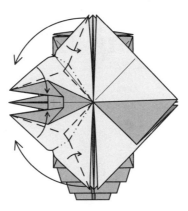

90. Fold a rabbit ear from the upper and lower white flaps, staggering their position slightly above and below the other three flaps.

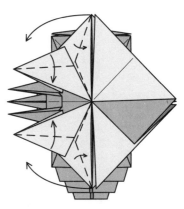

91. Fold a rabbit ear from each of the remaining flaps, staggering the points above and below the other five. It will be necessary to make small gussets along the center line of the model.

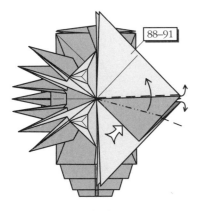

92. Repeat steps 88–91 on the right.

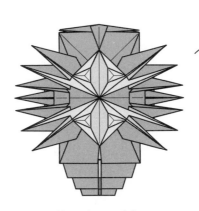

93. Turn the model over.

94. Pleat the topmost layers of paper. Shift the locations of the other pleats if necessary to even out the widths of the pleats.

95. Mountain-fold the edges underneath all the way around.

96. Pinch each leg in half. Round the body into a dome shape, adjusting the pleats as necessary to achieve a smooth, round body.

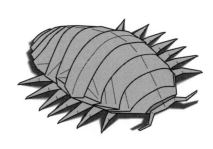

97. Pill Bug.

◆ Praying Mantis ◆

1. Fold and unfold.

2. Fold the top corner to the center and unfold. Make the crease sharp only where it crosses the vertical crease.

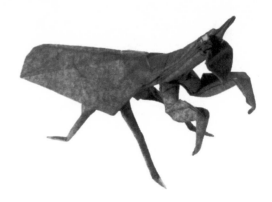

Praying Mantises are large, voracious predators. Using their strong forelegs, which are toothed along the edges, they snatch their prey from an ambush, and devour it completely with their strong jaws. When their forelegs are not in use, they carry them folded underneath their body, which gives them their characteristic "praying" appearance. They are highly desirable in gardens because they consume garden pests.

3. Fold the bottom corner up to the last crease, pinch, and unfold.

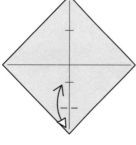

4. Fold the bottom corner up to the last crease, pinch, and unfold.

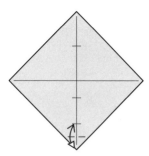

5. Fold the bottom corner up to the last crease, pinch, and unfold.

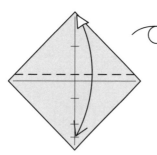

6. Fold the top corner down to the last crease and unfold; this time, make the crease sharp all the way across. Turn the paper over.

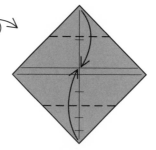

7. Fold the top corner down and the bottom corner up to meet at the last crease.

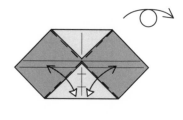

8. Fold and unfold. Turn the paper over.

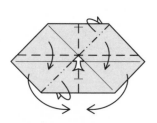

9. Fold a half-Waterbomb Base, half-Preliminary Fold.

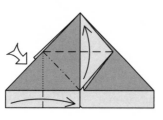

10. Swivel-fold.

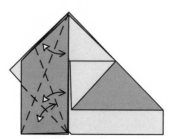

11. Fold and unfold.

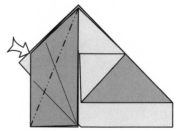

12. Open-sink the corner.

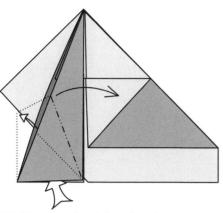

13. Open out the sink and push some paper up from the inside; pinch the excess paper in half and swing it over to the left.

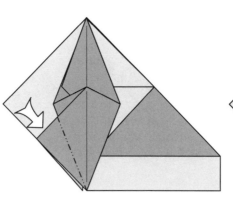

14. Reverse-fold the corner.

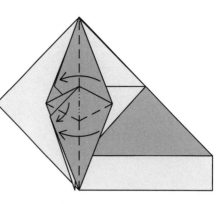

15. Pull down the edge of the pocket and fold the right layer back to the left.

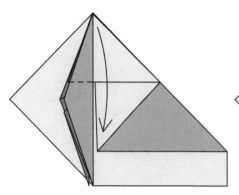

16. Fold one flap down.

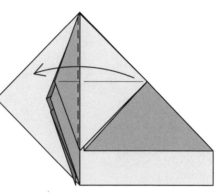

17. Swing one layer from right to left.

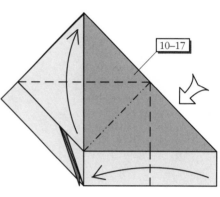

18. Repeat steps 10–17 on the right.

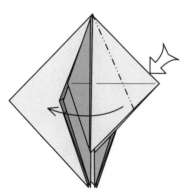

19. Squash-fold.

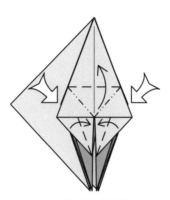

20. Petal-fold.

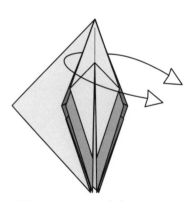

21. Unwrap a single layer.

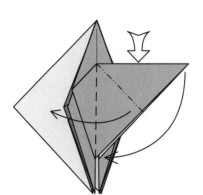

22. Squash-fold.

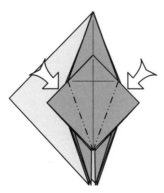

23. Reverse-fold the edges.

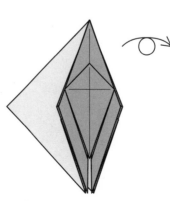

24. Turn the model over.

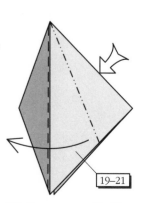

25. Repeat steps 19–21.

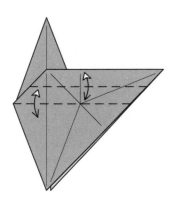 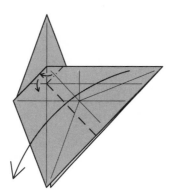 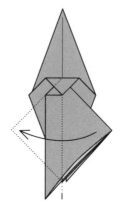 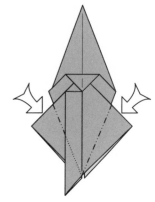

26. Fold and unfold.

27. Fold the flap down, using the newly made creases as a guide.

28. Reverse-fold a single layer out from the inside.

29. Reverse-fold the edges.

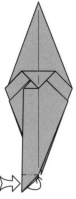 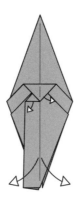 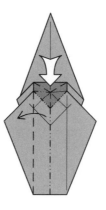 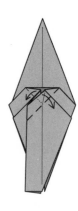

30. Reverse-fold the bottom corner.

31. Pull out the layers trapped under the triangular hood. The model will not lie flat.

32. Open-sink the shaded region and refold.

33. Flatten the sunk region.

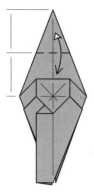 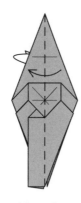 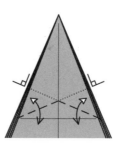 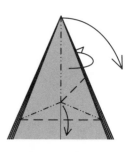

34. Fold and unfold through all layers of the thick point.

35. Fold one layer to the left in front and one to the right behind.

36. Top of the model. Fold and unfold.

37. Pleat and fold a rabbit ear from the thick point using the existing creases.

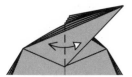 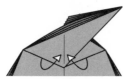 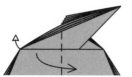 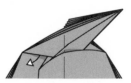

38. Fold and unfold through all layers.

39. Wrap one layer of paper to the front.

40. Fold one layer to the right, releasing the trapped paper at the left that links it to the next layer.

41. In progress. Pull paper out from here.

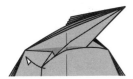

42. Close the model back up.

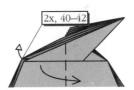

43. Repeat steps 40–42 on the next two layers.

44. Swing the point over to the left.

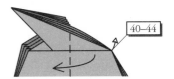

45. Repeat steps 40–44 on the right.

46. There are four edges on the top right; pull out as much of the loose paper between the third and fourth edges as possible. A hidden pleat disappears in the process.

47. Pull out the loose paper between the first and second layer.

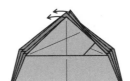

48. Swing the point back to the right.

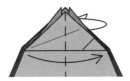

49. Repeat steps 46–47 on the left.

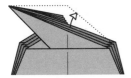

50. Fold and unfold.

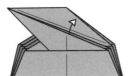

51. Open-sink the point. You will have to open out the top of the model somewhat to accomplish this.

52. Rearrange the layers at the top so that the central square forms a Preliminary Fold.

53. Fold one layer to the right in front, and one to the left behind. The model should be symmetric as in step 31.

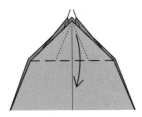

54. Petal-fold.

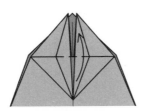

55. Fold the flap back upward.

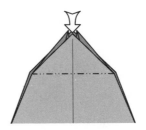

56. Closed-sink the point. (Be careful! It is very easy to rip the paper.)

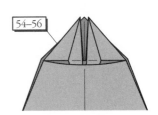

57. Repeat steps 54–56 behind.

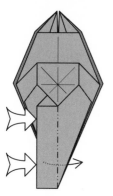

58. Reverse-fold the long edge all the way through the model (closed-sink the corner at the top).

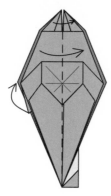

59. Fold two layers to the right (in the process, you undo the reverse fold you made back in step 15).

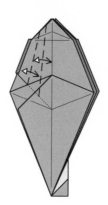

60. Crease into thirds.

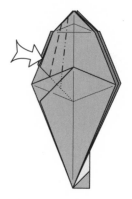

61. Sink (open at the bottom, closed at the top) the edge in and out on the existing creases.

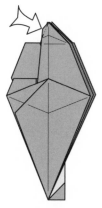

62. Sink the corner at the top.

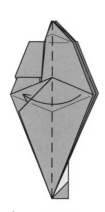

63. Fold one layer back to the left.

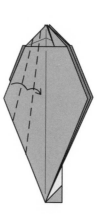

64. Fold one layer in thirds.

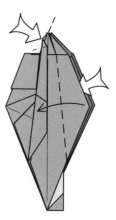

65. Crimp the top left corner. Fold one layer from the right to overlap the left layer, flattening the point behind.

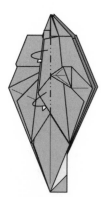

66. Mountain-fold the edge underneath.

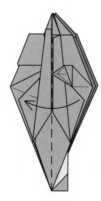

67. Fold one layer from right to left.

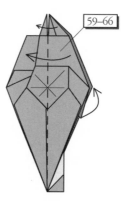

68. Repeat steps 59–66 on the right.

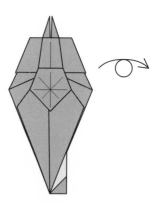

69. Turn the model over.

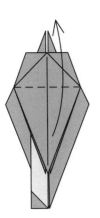

70. Fold one flap up.

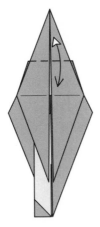

71. Fold and unfold; the crease lies on top of the horizontal edge of the layers behind.

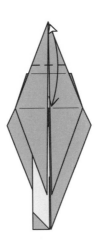

72. Fold and unfold.

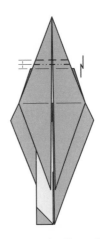

73. Pleat the flap. The mountain fold lies halfway between the valley fold and the other existing crease.

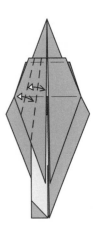

74. Crease into thirds.

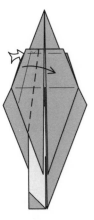

75. Fold the flap over on one of the creases you just made, and make a linked pair of swivel folds at the top.

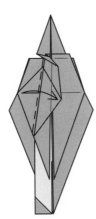

76. Fold the next layer over the top of the one you just folded.

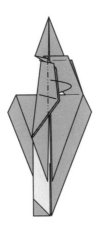

77. Mountain-fold both layers together.

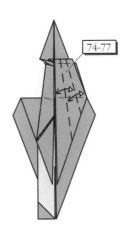

78. Repeat steps 74–77 on the right.

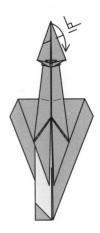

79. Fold the top point down to the right.

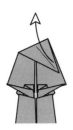

80. Unfold.

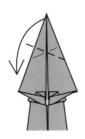

81. Fold the top down to the left.

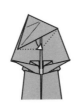

82. Pull out some loose paper.

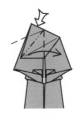

83. Squash-fold the flap over to the right.

84. Pull out some loose paper.

 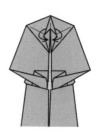 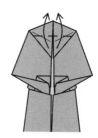

85. Reverse-fold the point.

86. Squash-fold.

87. Petal-fold.

88. Bring one layer to the front on each side.

89. Fold the two points upward (the exact amount isn't critical).

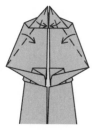 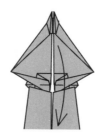 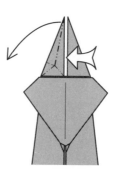 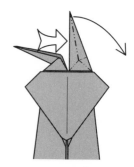

90. Narrow the two points and the sides of the main flap.

91. Fold the head down.

92. Double-rabbit-ear the left point.

93. Repeat on the right.

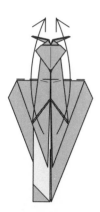 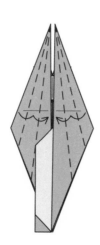 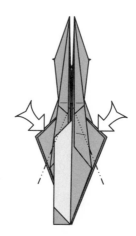 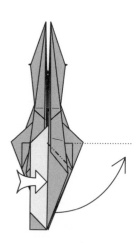

94. Fold up one point as far as possible on each side.

95. Fold each side in thirds.

96. Open-sink the near corner on each side.

97. Reverse-fold the point out to the side.

112 Origami Insects

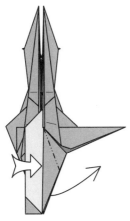

98. Reverse-fold the next point out to the side.

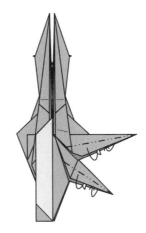

99. Narrow the legs with mountain and valley folds.

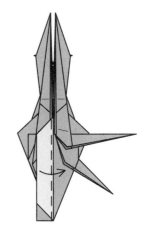

100. Swing the white layer over to the right.

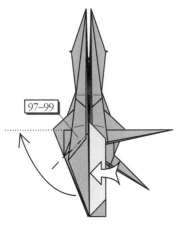

97–99

101. Repeat steps 97–99 on the left.

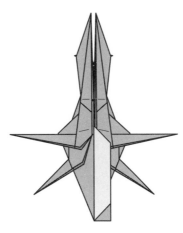

102. Turn the model over.

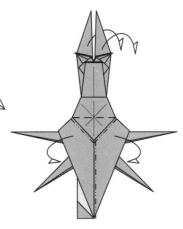

103. Fold the lower portion of the model in half, but keep the upper portion flat. Fold the forelegs down away from the body.

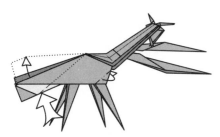

104. Mountain-fold the corner of the abdomen near the middle pair of legs. Repeat behind. Reverse-fold the white edge at the left of the abdomen upward.

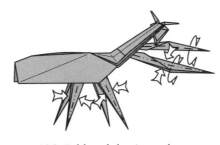

105. Fold each leg into a long, skinny rabbit ear.

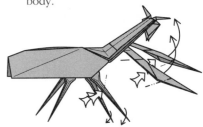

106. Bend the middle legs at the knee. Reverse-fold the forelegs up and down.

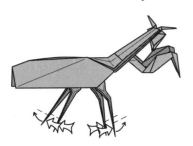

107. Bend the feet out flat.

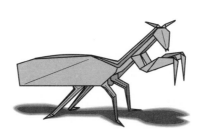

108. Praying Mantis.

◆ Stag Beetle ◆

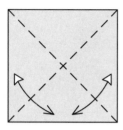

1. Fold and unfold along the diagonals.

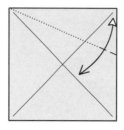

2. Fold and unfold along an angle bisector. Make the crease sharp only where it hits the edge.

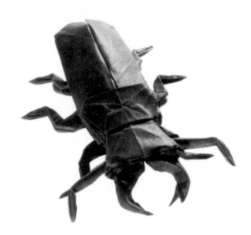

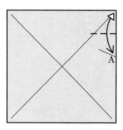

3. Fold the upper right corner down to point A and unfold. Make the crease sharp only as far as the diagonal.

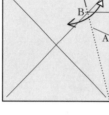

4. Fold a crease from the right corner through point B. Make the crease sharp only where it hits the top edge.

Stag Beetles are named for the large, branching jaws of the male, which resemble the antlers of a deer. Females also have jaws, but they are usually smaller. One of the largest species, the Elephant Stag Beetle, has jaws that can be as long as an inch. Although stag beetles are capable of giving a ferocious pinch, their jaws are so large and unwieldy that they have a difficult time righting themselves if they happen to get turned over.

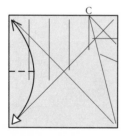

5. Fold the upper right corner down so that the crease runs through point C and unfold.

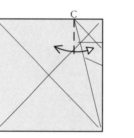

6. Fold and unfold along a vertical crease that runs through point C.

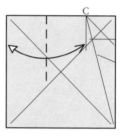

7. Fold the left edge over to point C and unfold.

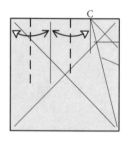

8. Fold the left edge over to the crease you just made and unfold; likewise, fold point C over to the same crease and unfold.

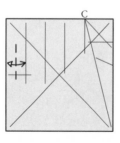

9. Fold the bottom corner up to the top corner and unfold.

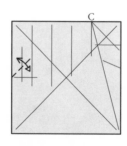

10. Fold the left edge over to the leftmost vertical crease and unfold.

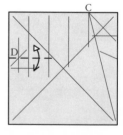

11. Fold along a diagonal crease and unfold.

12. The intersection of the two creases made in steps 10–11 is called point D. Make a horizontal crease that runs through point D.

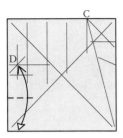

13. Fold the bottom edge up to point D and unfold.

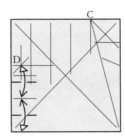

14. Fold the bottom edge up to the crease you just made. Likewise, fold point D down to the same crease and unfold.

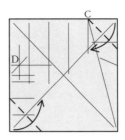

15. Fold the upper right corner down and the lower left corner up.

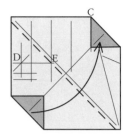

16. Fold the lower left corner to the upper right; the crease runs through point E.

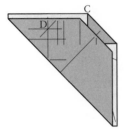

17. Rotate the model 3/8 of a turn clockwise.

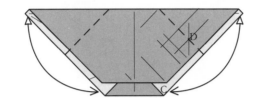

18. Fold the upper right corner down to point C and unfold. Repeat similarly on the left.

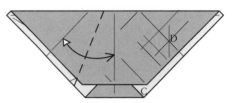

19. Fold the left flap so that the last crease you made lies along the center line.

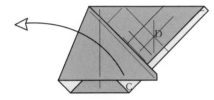

20. Unfold.

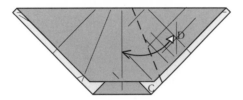

21. Repeat steps 19–20 on the right.

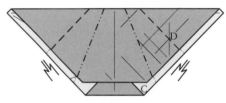

22. Crimp, using the crease you just made.

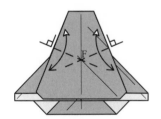

23. Fold and unfold; the creases run through point F.

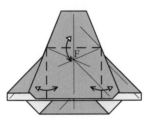

24. Fold and unfold.

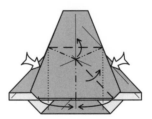

25. Squeeze the sides in and swing the excess paper to the right.

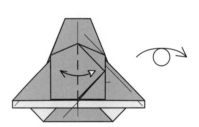

26. Fold and unfold. Turn the model over.

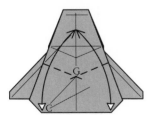

27. Fold point C up to lie along the center line so that the crease runs through point G. Repeat on the right.

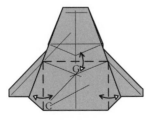

28. Fold and unfold.

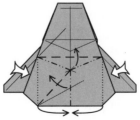

29. Squeeze the sides in and swing the excess paper to the left.

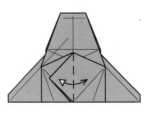

30. Fold and unfold.

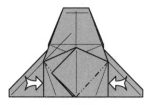

31. Reverse-fold two edges.

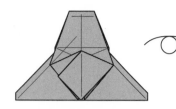

32. Turn the model over.

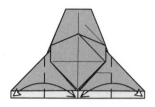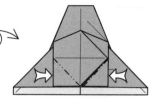

33. Reverse-fold two edges.

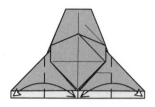

34. Fold and unfold.

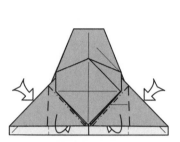

35. Reverse-fold two edges.

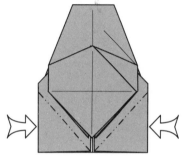

36. Reverse-fold two edges.

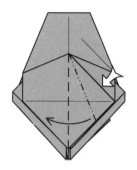

37. Squash-fold.

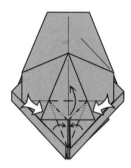

38. Petal-fold.

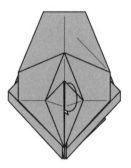

39. Tuck the point up inside the model.

40. Fold one layer over to the right. Crease firmly.

41. Fold and unfold along the center line.

42. Fold the next layer over to the right along the same vertical line. Crease firmly.

43. Fold and unfold.

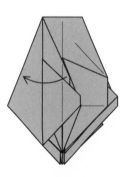

44. Unfold both flaps.

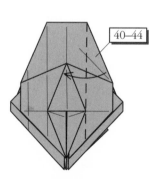

40–44

45. Repeat steps 40–44 on the right.

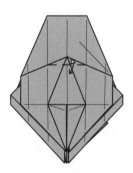

46. Crease lightly.

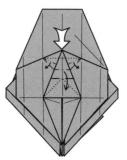

47. Spread-sink the top point.

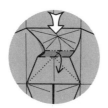

48. In progress. Flatten completely.

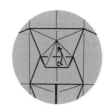

49. Fold and unfold.

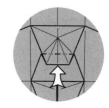

50. Closed-sink the point. This is easily done if you partially unfold the model.

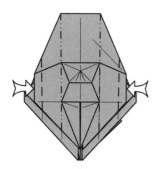

51. Open-sink the sides on existing creases.

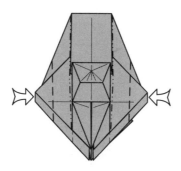

52. Open-sink the next pair of flaps.

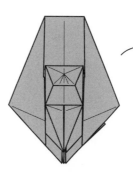

53. Turn the model over.

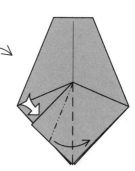

54. Squash-fold the flap.

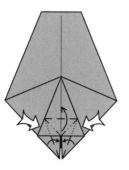

55. Petal-fold the edge.

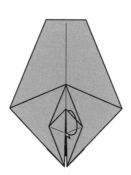

56. Tuck the flap underneath.

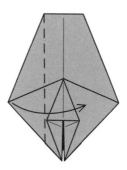

57. Fold one layer over to the right; the crease lies over a hidden edge.

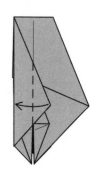

58. Fold the corner back to the left along the center line.

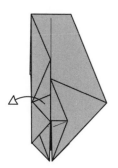

59. Unfold.

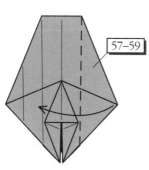

60. Repeat steps 57–59 on the right.

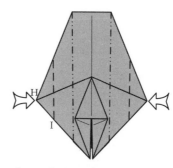

61. Sink the corners in and out. The sink is closed at point H (keep the pleat in place) and open at point I (don't lock the two bottom flaps together).

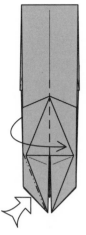

62. Spread-sink the corner.

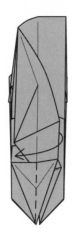

63. Close up the model.

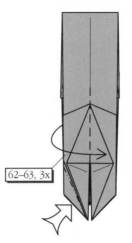

62–63, 3x

64. Repeat steps 62–63 on three corners.

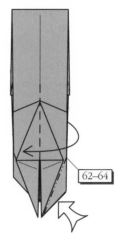

62–64

65. Repeat steps 62–64 on the right.

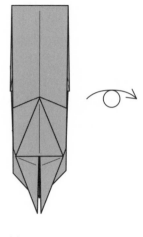

66. Turn the model over.

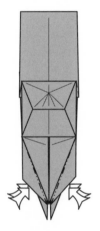

67. Spread-sink the three corners on each side (as in steps 62–63).

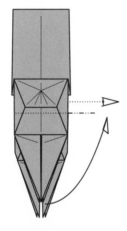

68. Fold the six lower points up so that they stand out from the rest of the model.

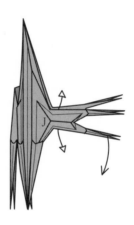

69. Side view. Open the region marked J out into a rectangle.

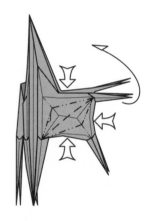

70. Add creases forming two rabbit ears across the rectangle and stretch the four upper points as far upward as possible.

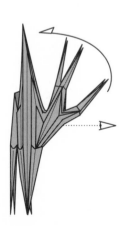

71. In progress. Flatten.

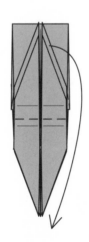

72. Fold the six points back down.

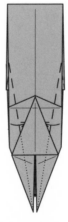

73. Valley-fold two edges in to the center line.

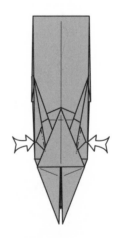

74. Sink the two corners.

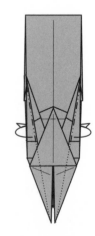

75. Mountain-fold the next pair of edges.

76. Valley-fold the next pair of edges.

77. Mountain-fold the next pair of edges.

78. Valley-fold the next pair of edges.

79. Fold six points back up to the top.

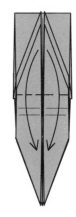

80. Fold one point down on each side.

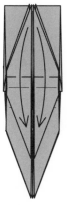

81. Fold one more point down on each side.

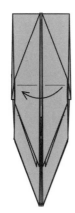

82. Fold one layer over to the left, releasing any trapped paper.

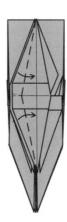

83. Fold a narrow rabbit ear.

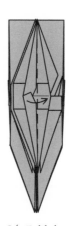

84. Fold the layer to the right.

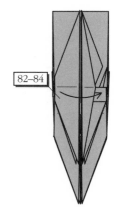

82–84

85. Repeat steps 82–84 on the left.

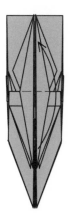

86. Fold one point up.

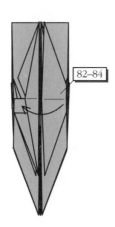

82–84

87. Repeat steps 82–84.

88. Fold one point up.

89. Fold one layer to the left.

90. Fold a narrow rabbit ear.

Stag Beetle 119

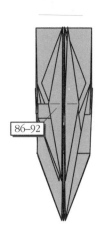
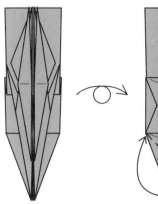
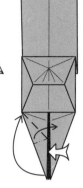

91. Close up the model.

92. Fold one point down.

86–92

93. Repeat steps 86–92 on the left.

94. Turn the model over.

95. Squash-fold the corner.

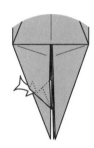

96. Fold a single layer outward on each side and squash-fold the point to the right.

97. Mountain-fold the corner underneath.

98. Close up the model.

99. Reverse-fold the corner.

100. Reverse-fold the hidden corner.

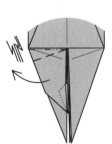
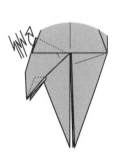
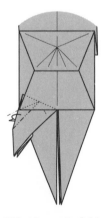
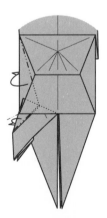
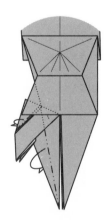

101. Crimp the flap to the left.

102. Disentangle the crimped layers.

103. Mountain-fold a single layer and swivel-fold the edge underneath the head.

104. Mountain-fold the next layer and the vertical edge (they are interlocked).

105. Mountain-fold the last layer and the vertical edge below it.

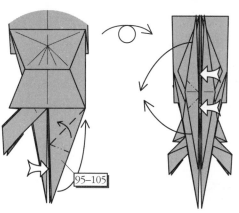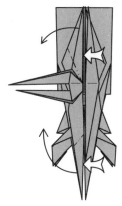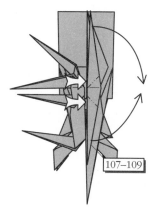

106. Repeat steps 95–105 on the right and turn the model over.

107. Reverse-fold two points as far as possible.

108. Reverse-fold the two remaining points.

109. Mountain-fold the edge.

110. Repeat steps 107–109 on the right.

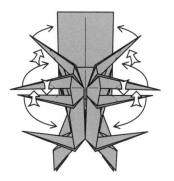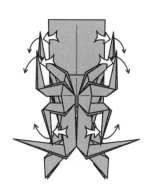

111. Reverse-fold all six legs.

112. Reverse-fold all six feet.

113. Turn the model over.

114. Reverse-fold two corners.

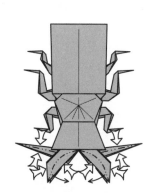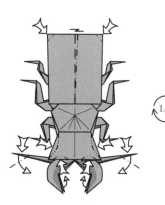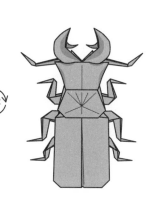

115. Mountain-fold two corners underneath.

116. Pinch the antennae in half. Pinch the jaws and curve them toward each other.

117. Final shaping. Squash-fold the tips of the antennae. Spread the points of the jaws. Reverse-fold the corners of the abdomen and crimp it in the middle. Rotate the model.

118. Stag Beetle.

◆ Paper Wasp ◆

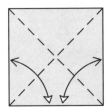

1. Fold and unfold along the diagonals.

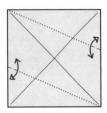

2. Fold and unfold along an angle bisector. Make the creases sharp only where they hit the edge.

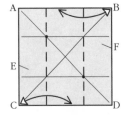

3. Fold the top edge AB down so that corner A hits point E; crease and unfold. Fold the bottom edge CD up so that corner D hits point F.

4. Fold edge AC in so that the crease hits the diagonal at the same place as in step 3. Repeat on the right with edge BD. Then rotate the model 1/8 turn counterclockwise.

The Paper Wasp is a very appropriate subject to be folded from paper. They are named as they are because they make their own paper, by chewing wood into pulp and mixing it with their saliva. The resulting material is molded into cells in which they lay their eggs and raise their larvae. Their paper-making ability is shared by several other members of the wasp family, including hornets. Unlike hornets, though, paper wasps are relatively tolerant of people and their nests are likely to be found under the eaves of buildings throughout North America.

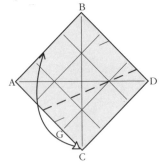

5. Fold point C up to lie on edge AB; point G lies on crease AD as well. Unfold.

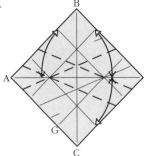

6. Repeat in 3 places. Turn the paper over.

7. Fold and unfold through the intersections shown.

8. Fold and unfold through the intersections shown.

9. Collapse the paper on the creases, bringing points D and A down while point C swings up to the left and B swings behind to the right.

10. Squash-fold corners C and B down using the existing creases.

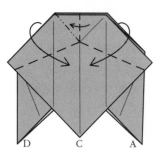

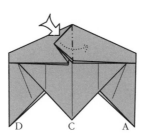

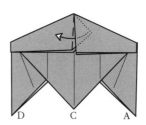

11. Fold a rabbit ear from the top of the model, folding two layers together as one.

12. Reverse-fold the double layer inside.

13. Pull out a single layer.

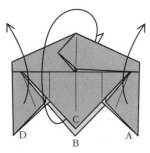

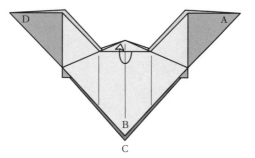

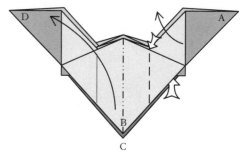

14. Carefully wrap layer C behind, allowing corners D and A to swing up. You will have to partially unfold the model to do this.

15. Pull some trapped paper out from under the little hood.

16. Pinch corner B in half and swing it up to the left.

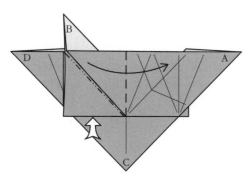

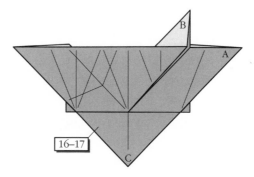

17. Squash-fold the horizontal edge and swing flap B over to the right.

18. Repeat steps 16–17 behind.

19. Crimp flap D over to the right, but first, look ahead at the next few steps to see creases that happen inside the model in the circled region.

20. Open out the pocket from underneath and begin to squash-fold the hidden edge upward.

21. Squash-fold the top edge and bring corners H and I together.

22. Finish making the crimp shown in step 19 and flatten the model.

23. Repeat steps 19–22 behind.

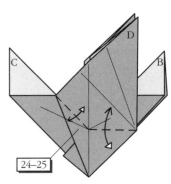

24. Fold and unfold through a single layer of paper.

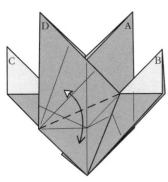

25. Fold and unfold through a single layer of paper.

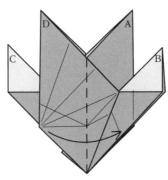

26. Fold flap D to the right.

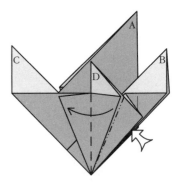

27. Repeat steps 24–25 on this side.

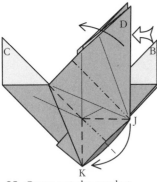

28. Open out the pocket between points J and K and bring point J down to point K; simultaneously squash-fold corner D symmetrically.

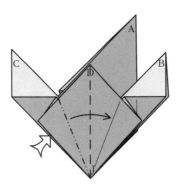

29. Squash-fold the edge.

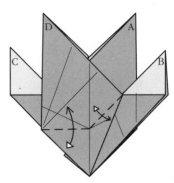

30. Squash-fold the other edge.

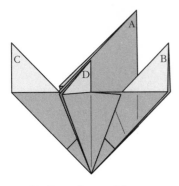

31. Turn the model over.

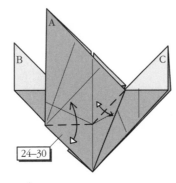

32. Repeat steps 24–30 on this side.

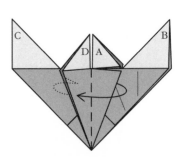

33. Fold one flap to the left in front and the corresponding flap to the right behind.

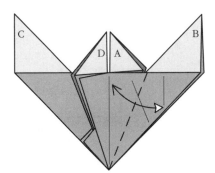

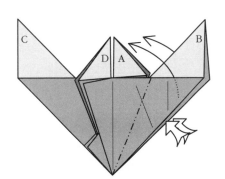

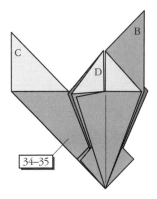

34. Fold and unfold through all layers.

35. Reverse-fold two edges. The two reverse folds are interlocked and must be perfomed simultaneously.

36. Repeat steps 34–35 on flap C.

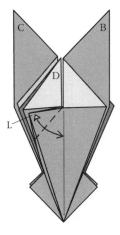

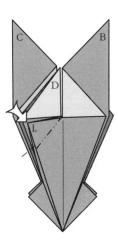

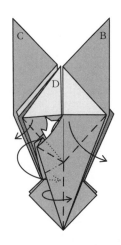

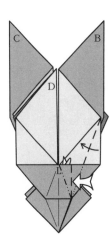

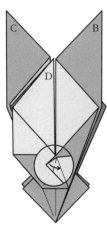

37. Fold corner L down to the center line and unfold.

38. Open-sink corner L.

39. Open out the sunken region and spread the raw edges to both the left and right.

40. Reverse-fold some paper behind point L.

41. Valley-fold the corner over to lock it.

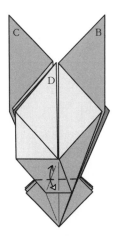

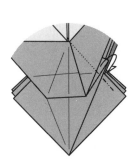

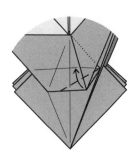

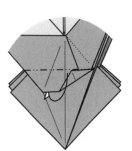

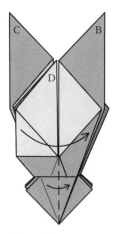

42. Fold and unfold lightly through a single flap.

43. Mountain-fold the hidden corner behind.

44. Fold the corner up to lie along the crease you made in step 42.

45. Mountain-fold the flap underneath.

46. Fold one layer over to the right.

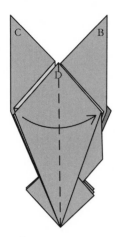

47. Fold another layer to the right.

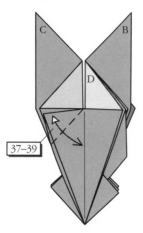

48. Repeat steps 37–39 on the newly exposed corner.

37–39

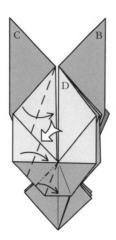

49. Crimp and pleat the left side.

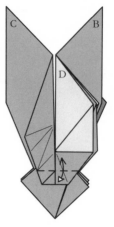

50. Fold and unfold lightly.

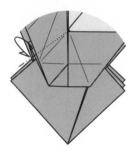

51. Fold and unfold, creasing lightly.

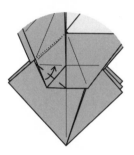

52. Fold two corners up to the crease you just made.

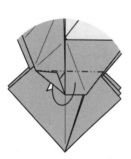

53. Mountain-fold the flap underneath on the existing crease.

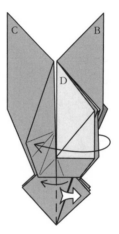

54. Fold the two layers of flap D over to the left, but hold all four of the square-cornered flaps at the bottom in place.

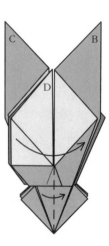

55. Fold a single layer of flap D back to the right.

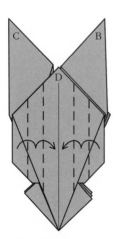

56. Fold the sides of flap D in thirds.

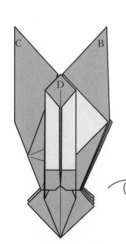

57. Turn the model over.

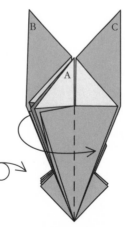

58. Fold four layers to the right.

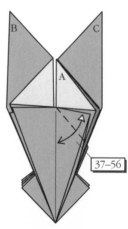

59. Repeat steps 37–56 on this side in mirror image.

37–56

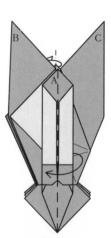

60. Fold one layer to the left. Repeat behind.

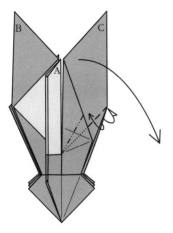

61. Crimp point C downward.

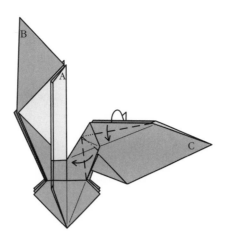

62. Swivel-fold. Repeat behind.

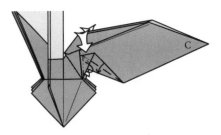

63. Swivel-fold. Repeat behind.

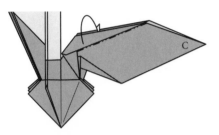

64. Mountain-fold the flap inside. Do not repeat behind.

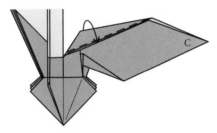

65. Tuck the flap into the pocket.

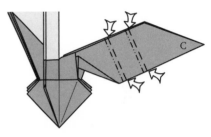

66. Carefully crimp the abdomen all the way around; each crimp forms a "tube within a tube."

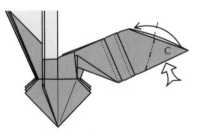

67. Reverse-fold corner C.

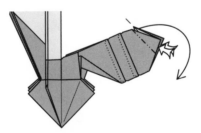

68. Petal-fold.

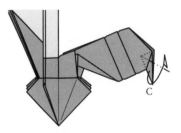

69. Mountain-fold the point behind.

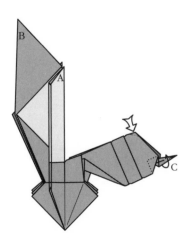

70. Reverse-fold the top corner. Valley-fold point C in half.

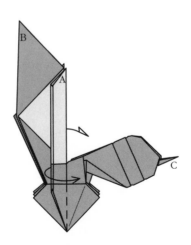

71. Fold both layers of flap A to the right. Repeat behind.

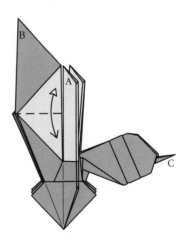

72. Fold and unfold through all layers.

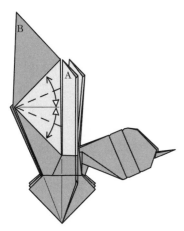

73. Fold and unfold through all layers.

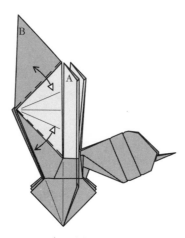

74. Fold and unfold through all layers.

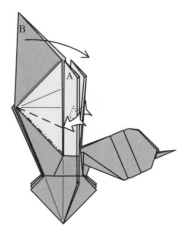

75. Crimp corner B to the right, both front and behind. You must make both crimps together.

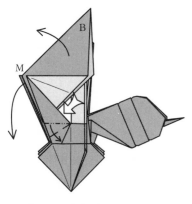

76. Spread the layers of the left flap symmetrically and crimp flap M downward.

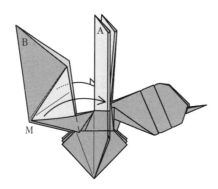

77. Fold one flap to the right in front and behind.

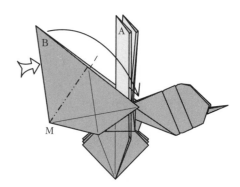

78. Reverse-fold corner B.

79. Reverse-fold two edges.

80. Fold one layer of flap M downward.

81. Fold flap B to the left and unfold.

82. Fold and unfold.

83. Fold flap B to the left.

84. Pull out some loose paper.

85. Squash-fold the corner and swing point B upward.

86. Pull out some loose paper.

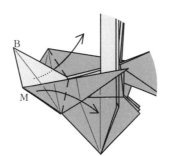

87. Open out flap B and flatten.

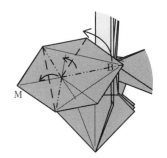

88. Pinch corner B in half and swing it upward.

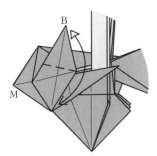

89. Fold and unfold.

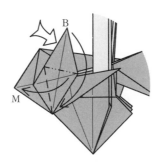

90. Squash-fold corner B.

91. Fold corner B upward.

92. Fold a rabbit ear from corner B with the point on the inside.

93. Pivot the region you have been folding by 90 degrees.

94. Reverse-fold the corners.

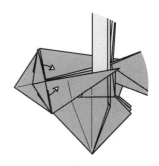

95. Pull out a layer of paper from each pocket (unsink).

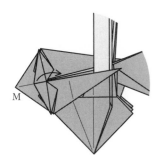

96. Fold one layer to the right.

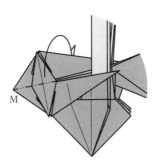

97. Mountain-fold the top half of flap M behind.

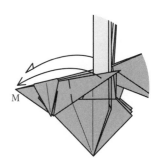

98. Fold a point to the left in front. Repeat behind.

99. Lift up a single layer as far as possible.

100. Wrap a raw edge from back to front.

101. Mountain-fold the white flap behind and tuck it into the pocket.

102. Repeat steps 99–101 behind.

103. Reverse-fold the point. Repeat behind.

104. Mountain-fold the edges of each antenna.

105. Fold the point up to the upper edge and unfold. Repeat behind.

106. Squash-fold one point on each side.

107. Reverse-fold corner M downward.

108. Reverse-fold both antennae.

109. Mountain-fold the edges of the jaw inside.

110. Valley-fold the remaining point to one side to lock the head together.

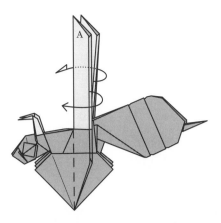

111. Fold one layer of each wing to the left.

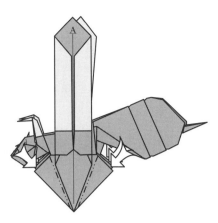

112. Reverse-fold three edges on the left and on the right.

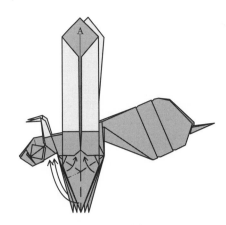

113. Fold a rabbit ear. Repeat behind.

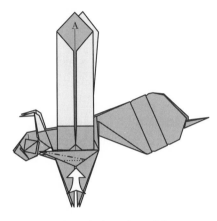

114. Sink the edge of the leg to narrow it. Repeat behind.

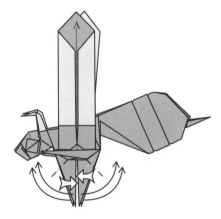

115. Reverse-fold four legs.

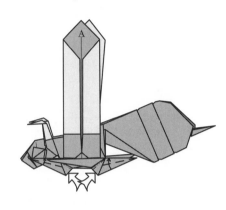

116. Narrow each leg with two reverse folds.

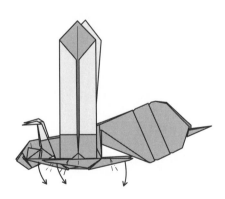

117. Crimp each leg downward.

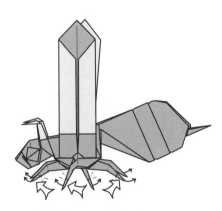

118. Reverse-fold a foot on each leg.

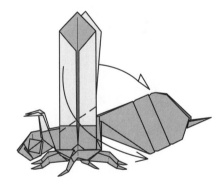

119. Fold a wing down on each side.

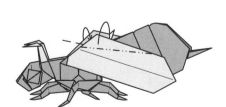

120. Mountain-fold the top of each wing.

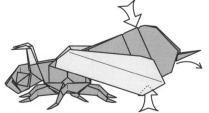

121. Squeeze the abdomen to make it three-dimensional. Curl the stinger.

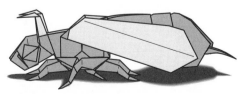

122. Paper Wasp.

◆ Samurai Helmet Beetle ◆

1. Begin with the colored side up. Fold in half vertically and unfold.

2. Fold the top edge down to the bottom; pinch in the middle and unfold.

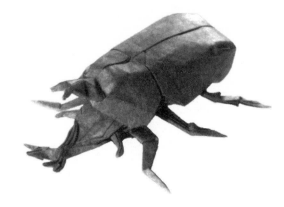

4. Fold the top edge down to the pinch mark; pinch and unfold. Fold the bottom edge up to the pinch mark; make the crease sharp all the way across the paper and unfold.

4. Fold the bottom edge up to the upper pinch mark; make the crease sharp all the way across and unfold.

The Samurai Helmet Beetle is one of the most common and most famous insects in Japan. Its Japanese name is *Kabuto Mushi* (*Kabuto* = samurai helmet, *Mushi* = beetle). It can be found throughout the islands and children often keep them as pets. They are quiet, don't eat very much, and housebreaking is not a problem! Because of the large number of points and their distinctive appearance, they are are also popular origami subjects.

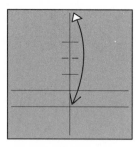

5. Fold the top edge down to the crease you made in step 3, make a pinch, and unfold.

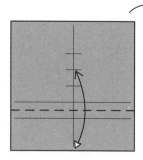

6. Fold the bottom edge up to the crease you just made; make the crease sharp all the way across and unfold. Turn the paper over.

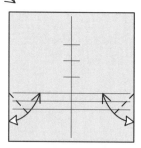

7. Fold the bottom left and right corners up so that the raw edges lie along the horizontal crease; unfold.

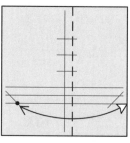

8. Fold the right edge over to touch the intersection shown; unfold.

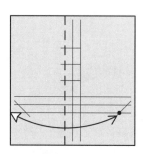

9. Repeat with the left edge.

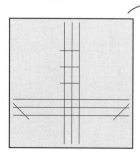

10. Turn the paper over.

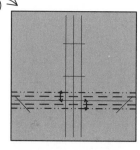

11. Pleat the paper, bringing the two mountain folds together; unfold.

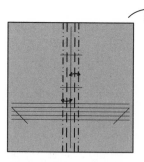

12. Pleat and unfold as you did in the previous step. Turn the paper over.

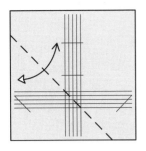

13. Crease lightly through the center of the crossing creases.

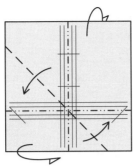

14. Using the existing creases, fold the paper into an asymmetric Preliminary Fold.

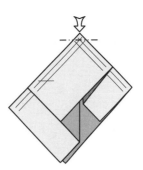

15. Open-sink the corner.

16. Mountain-fold two edges behind on the right and valley-fold two edges forward on the left.

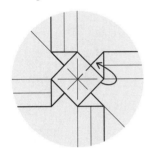

17. Open out the paper, keeping the folds made in step 16 in place.

18. Turn the paper over and rotate it so that two edges are horizontal.

19. Rotate the central square 1/4 turn clockwise.

20. Steps 21–29 will concentrate on the central region.

21. Lift up one corner of the central square.

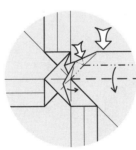

22. Squash-fold the edge symmetrically.

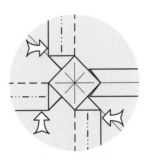

23. Squash-fold the remaining three edges in the same way.

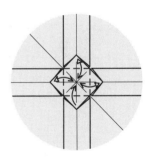

24. Fold the four corners into the center; unfold three of them, but leave the bottom corner in place.

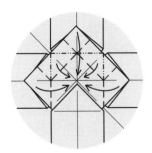

25. Fold five points (three corners, two edges) to the very center.

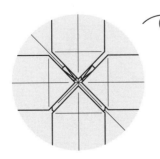

26. Turn the model over.

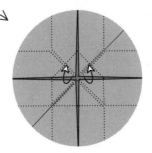

27. Tuck the two top corners into the pockets.

28. Mountain-fold the lower pair of corners.

Samurai Helmet Beetle 133

29. This part of the beetle is called the mesocentrum.

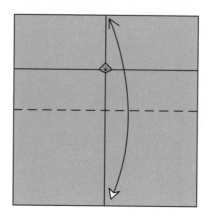

30. Fold the bottom half up to the top and unfold.

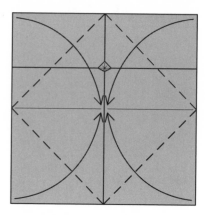

31. Fold the four corners in to the center of the paper.

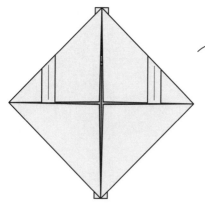

32. Turn the paper over.

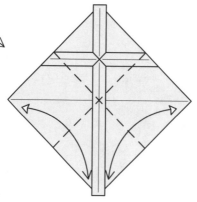

33. Fold and unfold.

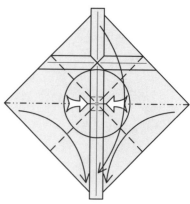

34. Fold a Preliminary Fold, but push in the sides of the vertical pleat so that its middle forms a tiny Waterbomb Base with the point going down.

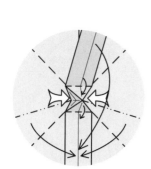

35. In progress.

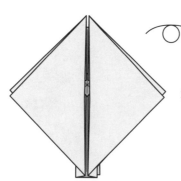

36. There should be two separate points at the top. Turn the model over.

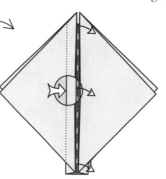

37. Reverse-fold one edge to the outside.

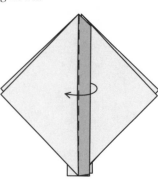

38. Fold the vertical edge to the left.

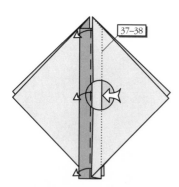

39. Repeat steps 37–38 on the right.

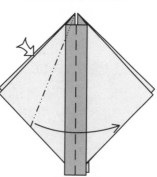

40. Squash-fold one flap.

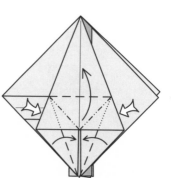

41. Petal-fold.

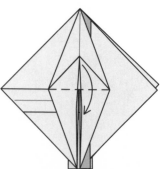

42. Fold the point down.

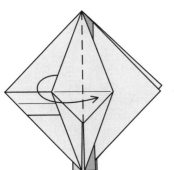

43. Fold one layer to the right.

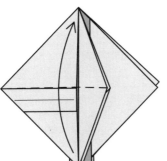

44. Fold one flap upward.

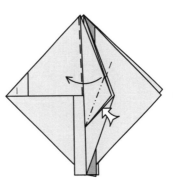

45. Spread-sink the corner. Make sure that the bottom corner of the spread-sink comes to a sharp point.

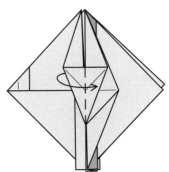

46. Fold one layer to the right.

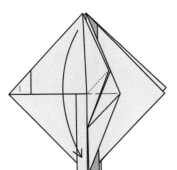

47. Fold the flap down, stretching a hidden layer.

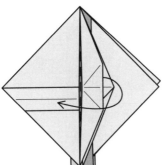

48. Fold one layer to the left.

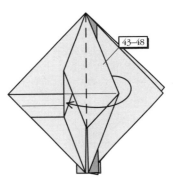

49. Repeat steps 43–48 on the right.

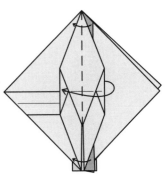

50. Fold one white layer and one colored layer to the left.

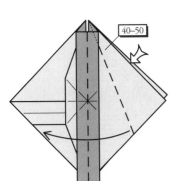

51. Repeat steps 40–50 on the right.

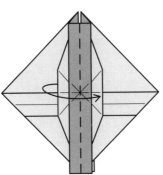

52. Valley-fold one colored layer and one white layer to the right.

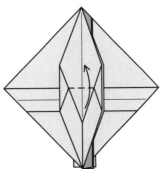

53. Fold the white point upward.

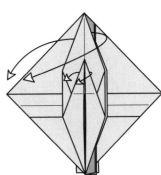

54. Unwrap a single layer of paper completely.

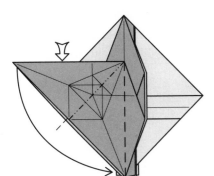

55. Squash-fold the corner.

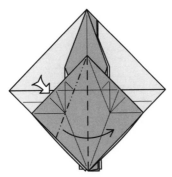

56. Squash-fold the edge.

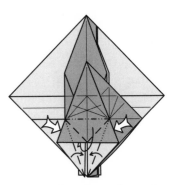

57. Tuck the edge underneath.

Samurai Helmet Beetle 135

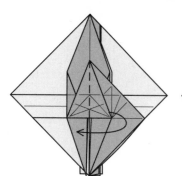

58. Fold one layer to the left.

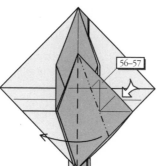

59. Repeat steps 56–57 on the right.

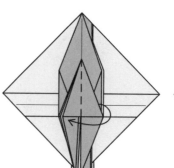

60. Fold one more layer to the left.

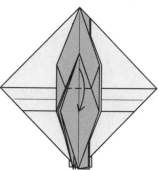

61. Fold the thick point down.

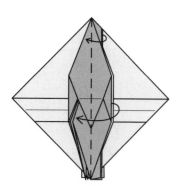

62. Fold two layers to the left.

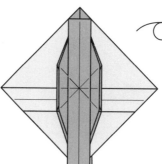

63. Repeat steps 52–62 on the right.

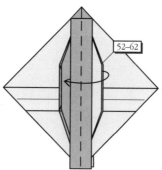

64. Turn the model over.

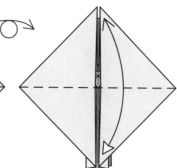

65. Fold one layer up and unfold.

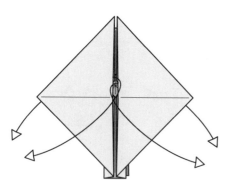

66. Unwrap one layer from each side.

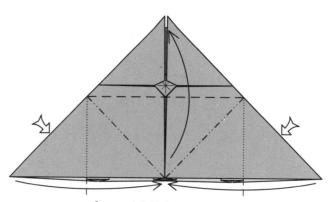

67. Petal-fold the middle upward and squash the sides inward.

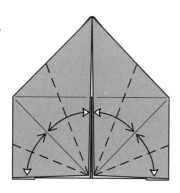

68. Fold and unfold along the angle bisectors.

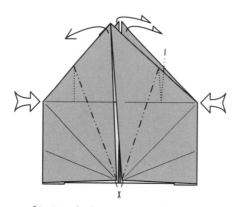

69. Stretch the top points in opposite directions as you sink the side corners. The model will not lie flat.

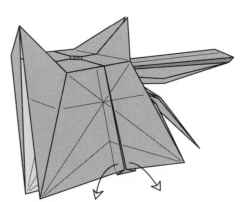

70. Spread the pleats along the bottom edge. Repeat behind.

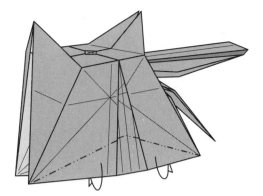

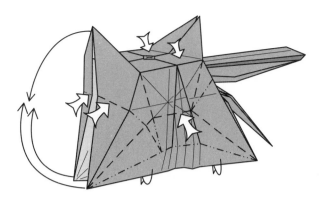

71. Mountain-fold the edge underneath. You should stretch out the pleats so that the folded part has no pleats at all.

72. Push in the sides and bring the three points at the left together. Begin flattening the model from top to bottom.

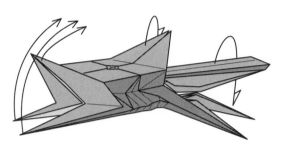

73. Rotate the model so that the left points point upward; flatten the model completely.

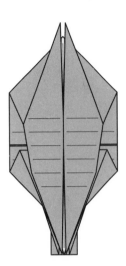

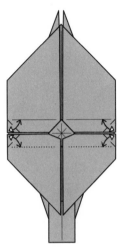

74. Turn the model over.

75. Fold and unfold.

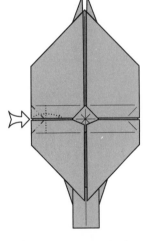

76. Sink the vertical edges. You will have to turn over and partially unfold the model to do this. Look ahead to the cut-away view in the next step to see what the folds look like on the inside.

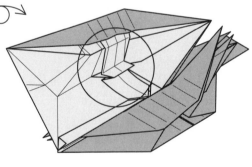

77. Steps 78–79 will focus on the region inside the circle.

78. Push in the edges, creating a tiny Waterbomb Base.

79. Repeat on the lower pair of edges.

80. Close the model back up and return it to the orientation of step 76.

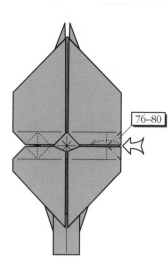

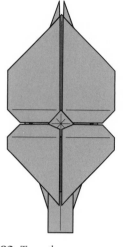

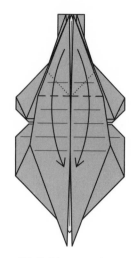

81. Repeat steps 76–80 on the right.

82. Turn the paper over from top to bottom.

83. Fold two points down, stretching the hidden layers.

84. Fold two more points down, stretching the hidden layers.

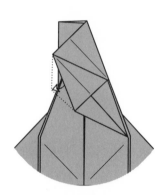

85. Steps 86–109 will focus on the top of the model.

86. Fold and unfold through two layers on each side.

87. Crimp and open out the right edge, squash-folding its top over to the left.

88. Pull out some loose paper.

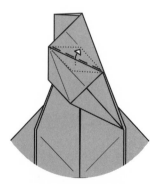

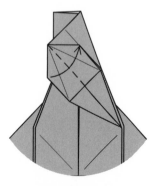

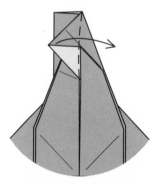

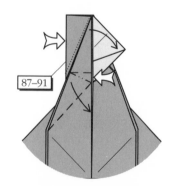

89. Sink the hidden point upward.

90. Fold in half.

91. Fold the point to the right along a vertical crease.

92. Repeat steps 87–91 on the left.

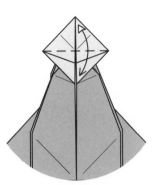

93. Fold and unfold.

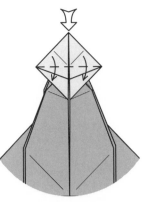

94. Sink the top corner downward.

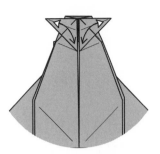

95. Fold and unfold.

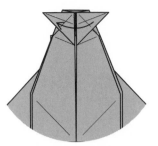

96. Fold one flap over to the left.

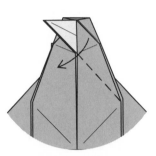

97. Fold one layer down.

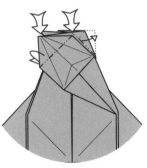

98. Sink the top left corner; at the same time, shift some paper at the top right to the right.

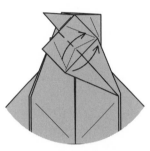

99. Close up the flap.

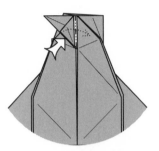

100. Reverse-fold the flap to the right.

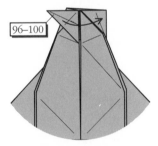

101. Repeat steps 96–100 on the left.

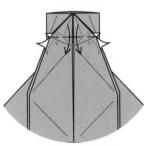

102. Squash-fold a hidden edge on both the left and right.

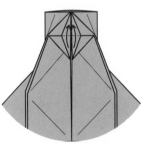

103. Fold the points back up.

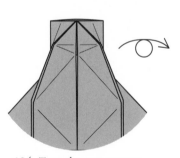

104. Turn the paper over.

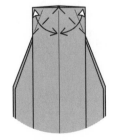

105. The near layers of paper are not shown in steps 105–109. Fold and unfold.

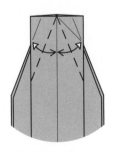

106. Fold and unfold.

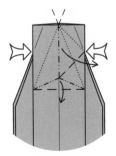

107. Squeeze in the sides and fold the excess paper over to the right.

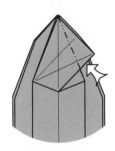

108. Reverse-fold the edge.

Samurai Helmet Beetle 139

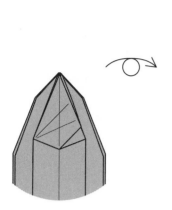 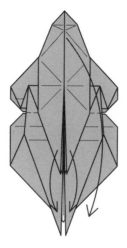 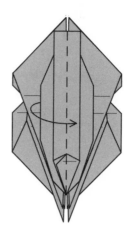 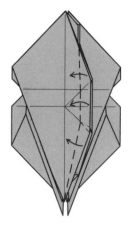

109. Turn the model over.

110. Fold the top point down, sliding the four downward-directed points down as well.

111. Fold three narrow layers to the right.

112. Narrow one edge with valley folds, incorporating a pleat where the valley fold changes direction.

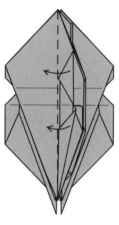 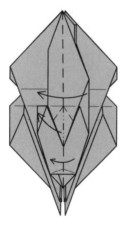 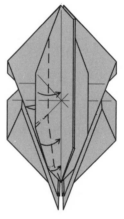 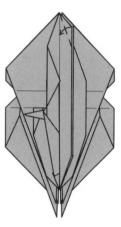

113. Fold one layer to the left.

114. Fold one edge to the left, incorporating the reverse fold shown.

115. Narrow the vertical edge with a valley fold, incorporating a pleat at each point where the fold changes direction.

116. Valley-fold the top right edge.

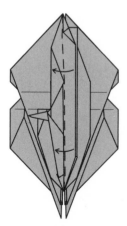 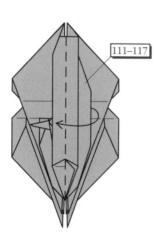 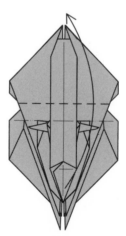

117. Fold one long edge to the left.

118. Repeat steps 111–117 on the right.

119. Fold one point upward, effectively undoing step 110.

120. Fold the edges in on both sides, incorporating pleats where the valley folds change direction.

121. Narrow the two points with valley folds front and behind.

122. Fold one point up on each side.

123. Fold the edges in on each side.

124. Fold two more points up.

125. Narrow each side with valley folds, incorporating pleats where the valley folds change directions.

126. Mountain-fold the remaining edges behind, swivel-folding the base of each point. The two upper edges get tucked inside the narrow flaps.

127. Fold two points down.

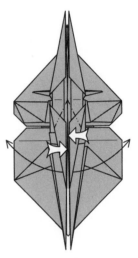

128. Reverse-fold two points out to the sides.

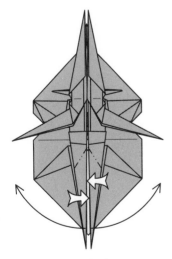

129. Reverse-fold two more points out to the sides.

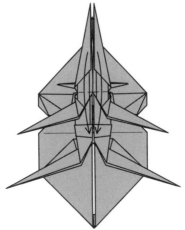

130. Fold the top two points down.

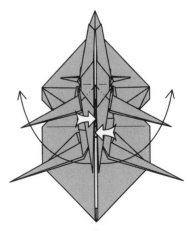

131. Reverse-fold the remaining pair of points out to the sides.

Samurai Helmet Beetle 141

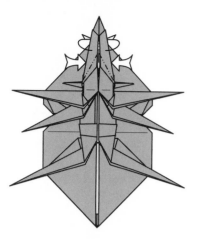

132. Fold a rabbit ear from the top flap with the point going away from you.

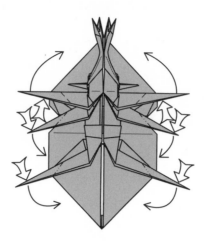

133. Reverse-fold all six legs.

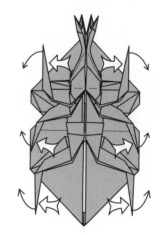

134. Reverse-fold all six feet.

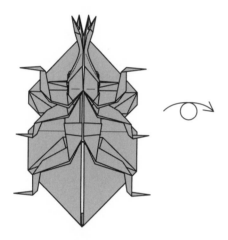

135. Turn the model over.

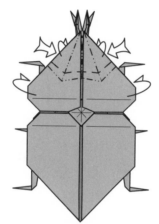

136. Simultaneously pleat the top of the model and mountain-fold its edges around to the rear. The point stands up and becomes three-dimensional.

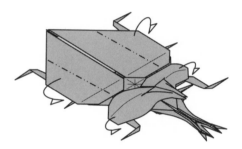

137. Curl the body to make it three-dimensional.

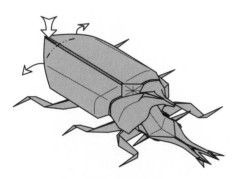

138. Push down the rear of the body and pull out two raw edges from each side.

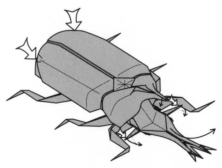

139. Sink the corners of the abdomen to round it. Curl the forward horn upward. Spread the two points on the upper horn apart. Round and shape the body.

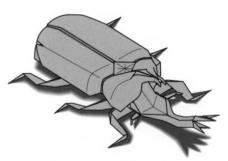

140. Samurai Helmet Beetle.

◆ Scorpion ◆

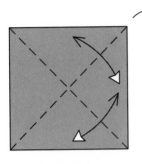

1. Fold and unfold along the diagonals. Turn the paper over.

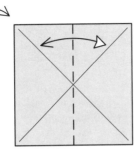

2. Fold and unfold vertically.

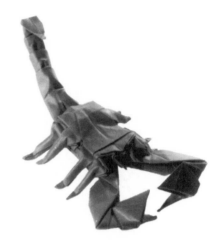

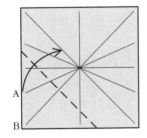

3. Fold the paper in half.

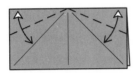

4. Fold and unfold along angle bisectors.

The Scorpion is not a true insect, since it has eight legs plus two claws. It is more closely related to spiders. All scorpions are poisonous, and can inject poison from stingers at the tip of their tails. Most American scorpion stings, while painful, are not dangerous. Some larger breeds may even be found for sale in pet stores.

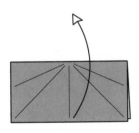

5. Unfold the square again.

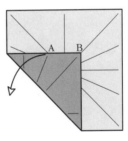

6. Fold the lower left corner up so point A lies on one diagonal crease and point B lies on the other.

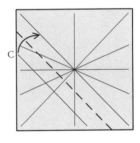

7. Unfold.

8. Fold the lower left corner up so point C lies on the diagonal.

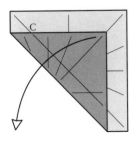

9. Unfold.

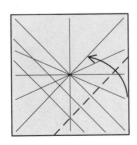

10. Repeat steps 6–9 on the other three corners.

11. Turn the paper over.

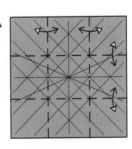

12. Fold and unfold. Turn the paper back over.

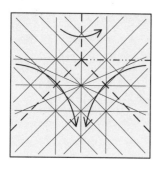

13. Fold a rabbit ear on existing creases.

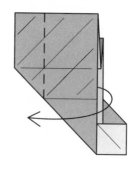

14. Squash-fold the edge upward on existing creases.

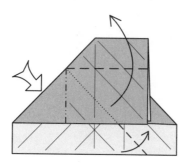

15. Fold one layer over to the left — the model will not lie flat.

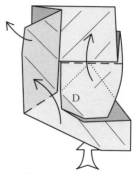

16. Pull layer D out and squash-fold the bottom flap upward.

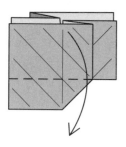

17. Fold one flap down.

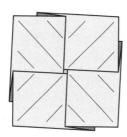

18. Turn the model over.

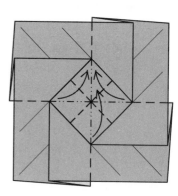

19. Fold a Preliminary Fold from the central square. The model will not lie flat.

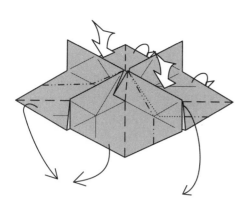

20. Squash-fold two edges and bring all four corners downward.

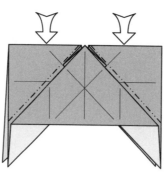

21. Reverse-fold the two remaining edges.

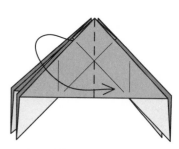

22. Fold a single layer of paper over to the right. The model will not lie flat.

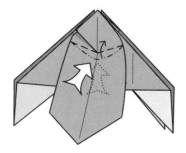

23. Put your finger up inside the flap and squash-fold it symmetrically.

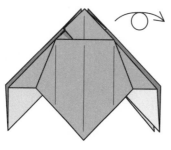

24. Turn the model over.

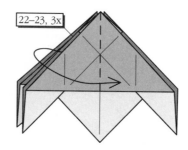

25. Repeat steps 22–23 on the other three flaps.

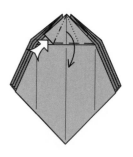

26. Petal-fold a single point downward.

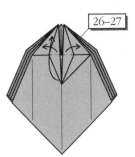

27. Unfold. Repeat steps 26–27 behind.

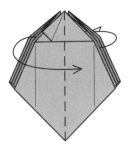

28. Fold two layers to the right in front and two to the right behind.

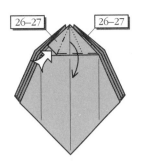

29. Repeat steps 26–27 here and behind. The slanted creases are already in place—but it's the horizontal valley folds that are important.

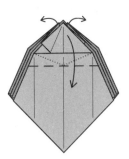

30. Open out the top of the model. Don't press it flat.

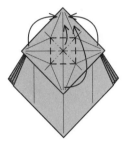

31. Close the top of the model back up, adding a tiny Waterbomb Base formed from existing creases in a single ply of paper. (Only the new creases are shown here.)

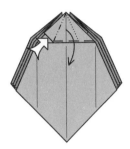

32. Petal-fold again as in steps 26–27. No new creases are made.

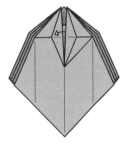

33. Pull a double layer of paper out from inside the pocket (closed unsink). See the next step for details.

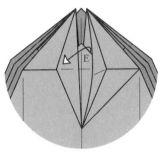

34. To perform step 33, grab the edge marked E and pull it out to the left.

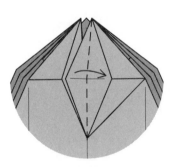

35. Fold one flap to the right.

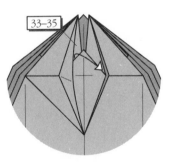

36. Repeat steps 33–35 on the left.

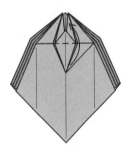

37. Fold the point upward.

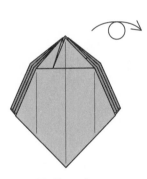

38. Turn the model over.

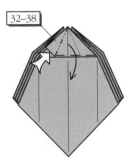

39. Repeat steps 32–38 on this side.

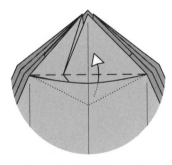

40. Grab the hidden edge and pull two layers of paper up out of the pocket (as in steps 33 and 34).

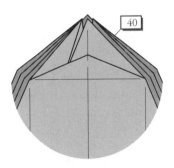

41. Repeat step 40 behind.

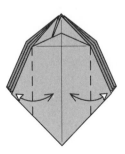

42. Fold and unfold through one flap on each side.

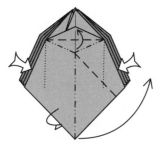

43. Mountain-fold one layer in half and swing the point over to the right; simultaneously push in the sides.

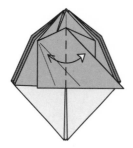

44. Fold and unfold.

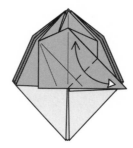

45. Fold and unfold.

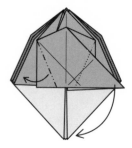

46. Unfold to step 43.

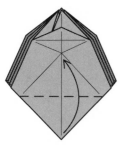

47. Valley-fold the point upward on the existing crease.

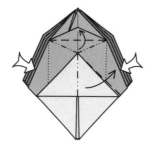

48. Refold as in step 43.

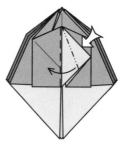

49. Squash-fold the white flap.

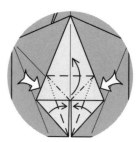

50. Petal-fold the white flap.

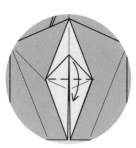

51. Fold the tip of the point down.

52. Sink the point up inside the model.

53. Unwrap a single layer of paper.

54. Petal-fold.

55. Fold the flap back down.

56. Fold the flap up to the right.

57. Unfold.

58. Fold the flap up to the left.

59. Pull out a single layer of paper.

60. Pinch the point in half and swing it over to the right.

61. Pull out a single layer of paper.

62. Fold and unfold.

63. Fold and unfold.

64. Open out the flap.

65. Fold the corner underneath on an existing crease.

66. Bring the corners together and crimp the top of the flap upward on existing creases.

67. Reverse-fold the edge.

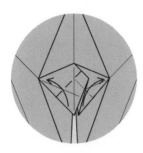

68. Fold the two points up to either side.

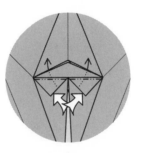

69. Reverse-fold two corners.

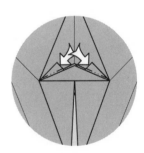

70. Reverse-fold two corners.

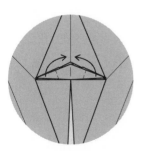

71. Valley-fold the two points upward and toward each other.

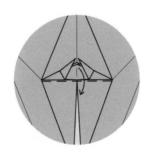

72. Fold the two points downward.

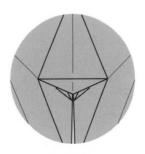

73. Like this.

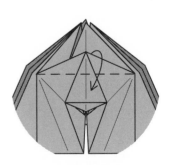

74. Fold two flaps down in front; repeat on the single flap behind.

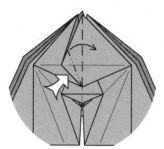

75. Spread-sink the corner; two layers go to each side (it doesn't matter which side the small, hidden layers go to). Repeat behind.

76. Crimp one of the two points at the top left downward symmetrically.

77. Stretch the left corner to the right as you squash-fold the hidden corner underneath; the model will not lie flat.

78. Repeat on the next corner.

79. Press the vertical creases to make them sharp; then fold both points back to the left and flatten the model.

80. Unfold to step 76.

81. Fold one layer over to the right.

82. Refold to step 80, incorporating the tiny Waterbomb Base shown here. The tip of the Waterbomb Base winds up touching point E.

83. In progress.

84. Finished. The x-ray line shows the location of the hidden Waterbomb Base. Repeat steps 76–83 on the right.

85. Fold down the top edge of a single layer.

86. Closed-sink the edge.

87. Spread-sink the next layer.

88. Fold the layer back up.

89. Fold the edge down.

90. Tuck the edge into the pocket.

91. Fold two flaps back upward.

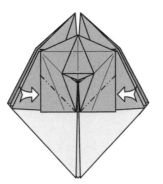

92. Reverse-fold the two corners.

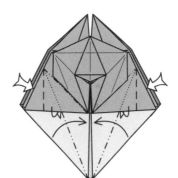

93. Reverse-fold the edges inward.

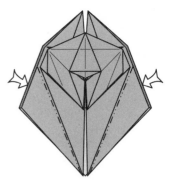

94. Reverse-fold the next set of edges.

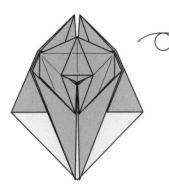

95. Turn the model over.

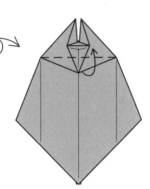

96. Fold one flap up.

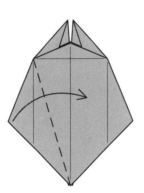

97. Fold one layer to the right.

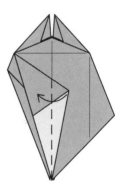

98. Fold the edge back to the left along a vertical crease.

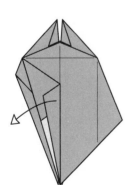

99. Unfold to step 97.

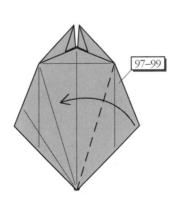

100. Repeat steps 97–99 on the right.

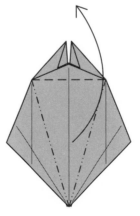

101. Petal-fold the point upward using the existing creases. The model will not lie flat.

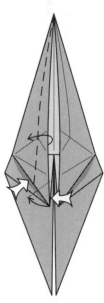

102. Valley-fold the raw edge to the left on the existing crease and squash-fold the point at its base to the left. This will allow the left side to flatten out.

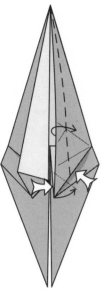

103. Repeat step 102 on the right. The model now lies completely flat.

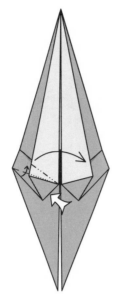

104. Squash-fold the point and swing the raw edge over to the right.

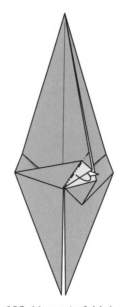

105. Mountain-fold the white part underneath.

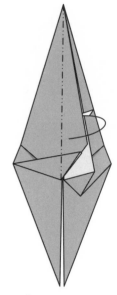

106. Mountain-fold the raw edge inside.

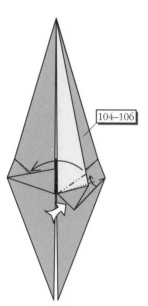

107. Repeat steps 104–106 on the right.

108. Turn the model over.

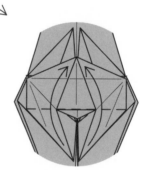

109. Fold one flap upward on both left and right.

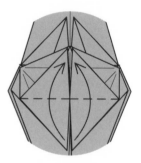

110. Fold the next pair of flaps upward along the same line.

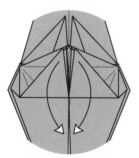

111. Unfold all four points.

112. Reverse-fold the corners out to the sides.

113. Reverse-fold the edges.

114. Crimp the two bottom points upward symmetrically. The horizontal folds are made on the creases you made in step 110.

115. Unfold the point on the right and swing a layer over to the left.

116. Fold the layer over to the left as far as it will go, squash-folding the hidden edge.

117. Reverse-fold the edge.

118. Fold one layer back to the right.

119. Fold the edge over and over to the left, dividing the flap into thirds.

120. Fold the edge in to the middle using existing creases.

121. Fold the vertical edge back to the right and re-form the reverse fold on the bottom point.

115–121

122. Repeat steps 115–121 on the left.

123. Mountain-fold the corners to line up with the creases.

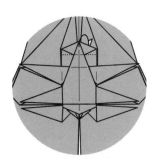

124. Mountain-fold a single corner at the top.

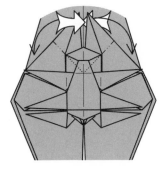

125. Reverse-fold the two remaining points symmetrically.

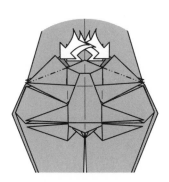

126. Reverse-fold four edges.

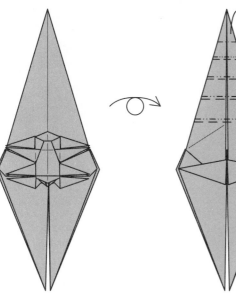

127. Turn the model over.

128. Mountain-fold the top point and pleat in four places.

129. Fold and unfold through the pleats.

130. Fold the edges in to the creases you just made.

131. Fold the edges in on the existing creases.

132. Fold and unfold.

133. Fold both tips up to the mark you just made, crease, and unfold.

134. Fold the right point upward so that its right edge aligns with the edge beneath it. Unfold.

135. Crimp the right point on the existing creases.

136. Pull out some loose paper. Repeat behind.

137. Outside-reverse-fold the tip.

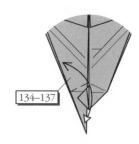

134–137

138. Repeat steps 134–137 on the left.

139. Fold a single layer (plus the short point at the top) over to the left.

140. Fold one layer back to the right along a vertical valley fold that lines up with the center line of the model.

141. Fold down the corner.

142. Fold the layer around and tuck it inside.

143. Fold the next layer over to the left.

144. Fold the flap to the right along a vertical valley fold and unfold.

145. Unfold to step 143.

146. Fold the flap over and over and tuck inside. Be sure the tiny triangle behind the upper leg (indicated by the x-ray line) is included in the fold.

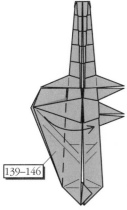

147. Repeat steps 139–146 on the left.

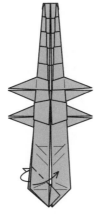

148. Outside-reverse-fold the end of the flap.

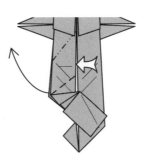

149. Reverse-fold the flap in and out.

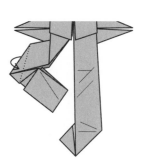

150. Tuck the corner into the pocket beneath it.

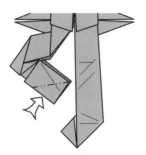

151. Reverse-fold the corner.

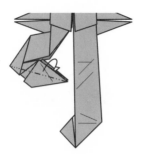

152. Mountain-fold the edge underneath.

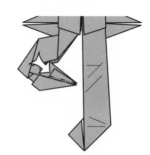

153. Reverse-fold the edge.

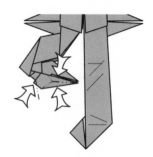

154. Shape the claw and pinch the near pincer.

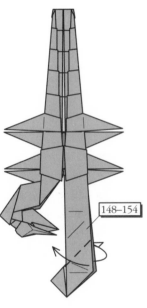

148–154

155. Repeat steps 148–154 on the right.

156. Turn the model over.

157. Pinch all of the legs in half. Fold their tips out to make feet. Squeeze the tail and curve it upward over the body. Shape the body.

158. Fold a tiny rabbit ear on the tail to make a stinger.

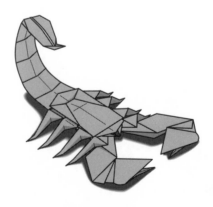

159. Scorpion.

Acknowledgments

I am indebted to many folders who have contributed to my work, both through their designs and through their suggestions for the presentation of origami instructions. I am particularly indebted to the legions of proofreaders who found numerous mistakes in the early drafts of the diagrams, and who made many helpful suggestions for clarity; they include Toshi Aoyagi, Steve Matheson, Marc Kirschenbaum, and several members of the *Origami Tanteidan*, Fumiaki Kawahata, Seiji Nishikawa, Issei Yoshino, Yoshihisa Kimura, and Masao Hatori. A special thank-you goes to Marc Kirschenbaum, Toshi Aoyagi, Peter Engel, Terry Hall, and Ron Levy, who folded their way through the entire book, pointing out errors and opportunities for clarification, and to Diane Lang and my editor at Dover, Philip Smith, who caught still more errors and inconsistencies while there was still time to fix them! Needless to say, any remaining mistakes are entirely my own. I would also like to thank the *Tanteidan*, Makoto Yamaguchi, *Gallery Origami House*, Kazuo Kobayashi, and *Origami Kaikan* for many of the beautiful papers that I used for the models in the photographs. An extra-special thank-you is due my wife, Diane, for her expert advice, editing, proofreading, and patience in the construction of this book.

Sources

If you would like more information about the basics of origami, the following are excellent books for beginners:

Robert J. Lang, *Origami Animals* (New York: Random House, 1992).
Robert J. Lang, *The Complete Book of Origami* (New York: Dover Publications, 1989).
John Montroll, *Easy Origami* (New York: Dover Publications, 1992).

If you are interested in additional challenging designs, there are a number of books that should inspire and challenge you. They include:

John Montroll and Robert J. Lang, *Origami Sea Life* (New York: Dover Publications, 1989).
John Montroll, *African Animals in Origami* (New York: Dover Publications, 1991).
John Montroll, *Origami Inside-Out* (New York: Dover Publications, 1993).

There are many origami organizations worldwide that stock books, paper, and other origami supplies. Many of them also publish magazines that contain instructions for new and unpublished models. There are also often local or regional folding groups in the larger cities. For information on origami organizations and publications, you may write to the organizations listed below (please send a self-addressed envelope with two first-class stamps):

Origami U.S.A.
15 W. 77th Street
New York, NY 10024-5192
U.S.A.

British Origami Society
c/o Peter Ford, General Secretary
11 Yarningdale Road
King's Heath, Birmingham B14 GLT
England

Nippon Origami Association
1-096 Domir Gobancho
12 Gobancho, Chiyoda-Ku
102 Tokyo Japan